Francisco Asensio Cerver

PASTELS

for Beginners

KÖNEMANN

Copyright © 1999 Könemann Verlagsgesellschaft mbH
Bonner Straße 126, D-50968 Cologne

Original title: Pastel
Managing editor, text, layout and typesetting: Arco Editorial, S.A.

Translation from Spanish: Harry Paul Carey
English language editor: Thérèsa Wassily Saba
Project coordinator: Kristin Zeier
Cover design: Peter Feierabend, Claudio Martinez
Production manager: Detlev Schaper
Printing and binding: EuroGrafica, Marano Vicenza
Printed in Italy

ISBN 3-8290-1934-3

10 9 8 7 6 5 4 3 2

CONTENTS

Materials

A BRIEF HISTORY OF PASTELS

Pastel is a painting and drawing medium that goes back to the eighteenth century, although many earlier painters had already used similar methods for drawing. The widespread acceptance of this medium by painters meant that soon a great number of artists began to use it, and it caught on to such an extent that it competed with oil painting. Great artists who adopted it as their medium include Rosalba Carriera, Degas, Manet, Odilon Redon, Picasso and many others.

Pastel can be used in diverse ways. Depending on the artist's intention, it can be used with techniques totally related to drawing or alternatively using a pictorial method. In these first pages we are going to show a complete product range: some of which are absolutely necessary to put the technique into practice. Others are accessories which put the final touches to the application of the technique. Of course, it is not necessary for the beginner to buy all the materials that are listed. It is important to know of their existence and to be able to decide which ones must be used on specific occasions, and what tools and presentation are the most suitable as the work progresses.

The first point to bear in mind is that pastel is a pictorial medium which can be treated like any other normal drawing procedure. In fact, in the first exercises we are going to use a style similar to drawing to explore the possibilities that pastel offers to this technique. You can start to draw with one or two pastel sticks and a sketch pad, which can be acquired along with the paper in any art supplies shop.

▲

▼

The beginner will soon realize that pastel is a highly unstable medium. The procedure allows the stroke to be rubbed out or blurred on the paper with the fingers. The colors, too, can be dirtied just as easily: this means that it is necessary to use a cloth. Have one handy from the start so that you can wipe your fingers.

Materials

PASTEL

Pastels come in a stick form composed of color pigment, and plaster or white ground chalk, all stuck together with arabic gum, also called binder. When the mixture of the three products has been made, it is moulded and allowed to dry. This means that its composition is one of the most straightforward of all the pictorial media, but despite this, it has many different qualities that offer a host of effects.

▶ *When you are starting out with pastel technique, it is essential to use high quality material. Good pastels are brightly colored, shiny and break easily.*

▶ *Different pastels have different qualities: oil pastels are denser and more waxy than normal pastels. They can be used for all the standard pastel applications. However, the stumping effect they give is not so uniform as they are manufactured with oil instead of gum, facilitating their mixture with oil paints. Several varied effects can be created when the stroke is diluted with turpentine.*

permanent white	101 Blanco permanente	101 Blanc permanent	101 Bianco
cadmium citron	107 Amarillo cadmio limón	107 Cadmium citron	107 Giallo cadmio limone
orange	111 Naranja	111 Orange	111 Arancione
vermillion dark	114 Bermellón oscuro	114 Vermillon foncé	114 Cinabro scuro
carmine extra fine	116 Carmín extrafino	116 Carmin extra-fin	116 Carminio
Bluish purple	139 Púrpura azulado	139 Violet bleuâtre	139 Lacca viola bluastra
Light blue	158 Azul claro	158 Bleu clair	158 Azzurro
Prussian blue	161 Azul Prusia	161 Bleu de Prusse	161 Blu di Prussia
Leaf green	178 Verde hoja	178 Vert feuille	178 Verde foglia
Pea green	187 Verde primavera	187 Vert printemps	187 Verde brillante
Van dycke brown	220 Marrón Van-Dyck	1B7 Brun Van-Dyk	220 Marrone Van-Dyck
Ivory black	250 Negro marfil	250 Noir d'ivoire	250 Nero avorio

RETACOLOR

▼ *Colored chalks are in fact hard pastels, but they come in a more limited range. The advantage of hard pastels is that they produce a more defined line, which is good for outlines and small details. However, they restrict the stumping effects that you can achieve. Artists use soft pastels when they need versatility.*

◀

This is how pastels are mixed with linseed oil or oil paints.

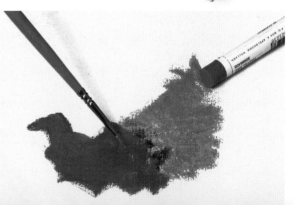

COLOR RANGES

As said before, pastels contain a neutral component that gives the bar a certain hardness. This element is white chalk which comes from Spain. Although it is a completely white element, it does not have the properties of a pigment. This means it does not paint, although, as will be seen throughout the chapters of this book, the luminous qualities of the pastel can be spoiled if you try to mix the colors on the paper.

◀

The purity of pastel colors is dulled when they are mixed because the chalk ingredient which gives stability to the stick starts to show through and takes away brightness and freshness from this medium. This image shows how the colors are spoiled by mixing.

It is this resistance to being mixed which has meant that pastels are produced in extensive color ranges with a great variety of tones. The ranges are so extensive that each artist can make up their own palette according to their requirements. To start practicing you can use a simple box like the one below.

▲

You will be able to find special ranges for specific types of subjects, for example for portraits in art supplies stores.

◀

7

OTHER RETAIL FORMATS

Pastels can come in many forms. Some artists opt for a personal selection of the colors, which explains why there is such a wide range in fine art shops. Other artists are perfectly happy with the retail ranges.

Not all of the pastel types are sold in wide ranges or with different packaging. Some high quality pastels are only available in a limited number of tints. It is worth remembering that you can also buy pastel pencils. Their characteristics are the same as sticks but they can be used like a normal pencil.

▼ **Thick pastels.** *This form is not the most common. The diameter of these pastels is larger than usual. They are normally made of high quality materials and in very small ranges. Their price is in line with their mass: that is to say expensive. These crayons are used by professionals who prefer large-scale formats and gestural pieces.*

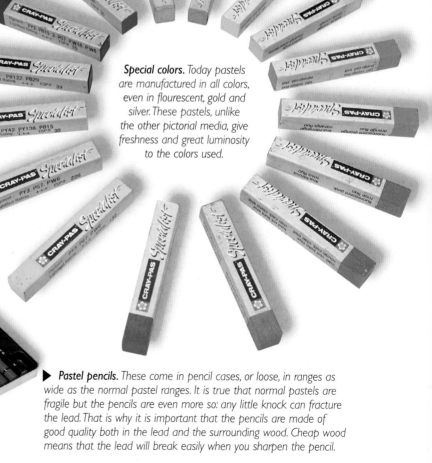

Special colors. *Today pastels are manufactured in all colors, even in flourescent, gold and silver. These pastels, unlike the other pictorial media, give freshness and great luminosity to the colors used.*

▶ **Pastel pencils.** *These come in pencil cases, or loose, in ranges as wide as the normal pastel ranges. It is true that normal pastels are fragile but the pencils are even more so: any little knock can fracture the lead. That is why it is important that the pencils are made of good quality both in the lead and the surrounding wood. Cheap wood means that the lead will break easily when you sharpen the pencil.*

CLEANING

When a beginner starts to paint he or she will immediately realize that pastels break quite often. The sticks that they have just taken out of the perfectly ordered box soon become an endless collection of little stubs that quickly get dirty as they rub against each other. In the pastel technique, keeping your hands and the pastels clean is fundamental.

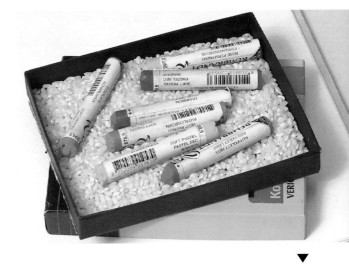

Pastels are very pure colors. Therefore, any contact with other pastels dirties them easily. Before starting work they must be cleaned so that they do not spoil the other colors on the paper. One way of cleaning them if there are only a few pastels is by carrying them inside a case with rice grains. The movement rubs the rice against the pastels and keeps them clean.

▶ *A box like this one is a handy way of storing pastels that have been bought loose. The case should have little compartiments to enable you to separate the color ranges, and to prevent them from bouncing around and rubbing against each other.*

The corrugated sponge lining inside the box is one of the best forms of protection. This is why, even if the sticks have been broken and are loose, they will always be better off cushioned than beging loose in the box. It is one way of having the sticks on display with no risk of them dirtying each other.

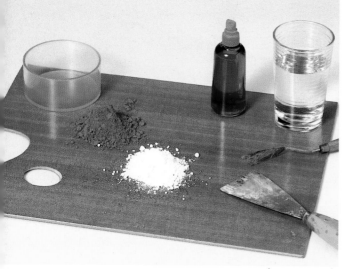

MAKING A PASTEL

▶ **1.** *The following materials and ingredients are needed to make a pastel stick: a spatula to mix the paste, another spatula to stir the color in the container, a container in which the proportions can be mixed, the pigment for the color, precipitated chalk, gum arabic (also called tragacanth), and a smooth surface that may be made of marble or crystal, or a large painter's palette.*

This point is interesting because it helps us to understand what advantages we have when using a pastel stick. Whatever the painting method is, it is important that the painter at least knows how the paint is made; of course this does not mean making your paints, unless you wish. In general mixing paints is not difficult, but it is laborious. Unless one has some experience in doing it, the results often do not turn out according to plan.

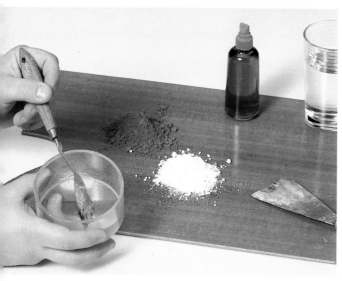

▶ **2.** *In a container, make the medium that is going to be used to bind the pigment: it is composed of water and gum arabic. The right proportion is a few drops of gum arabic for every tablespoon of water. Not all the colors require the same proportions. You have to stir it sufficiently, so that the gum and the water form a homogeneous mix.*

If you have left over stubs, which are too small to use, you can put them through the same process. They have to be pulverized in a mortar, but do not add dampened chalk. Mix the resulting powder with a tablespoon of water and add two drops of gum arabic.

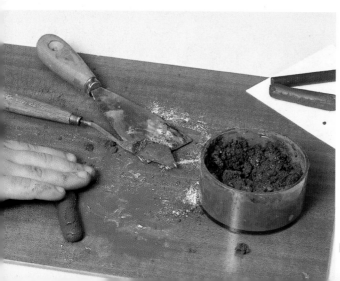

▶ **3.** *Now mix the dampened chalk with the solution that you have just made. If the paste is somewhat dry, add a little water until it is softened. The color pigment is now kneaded in. If the chalk is too damp, the pastel stick will be brittle. Once the form of the stick has been moulded, place it on some paper and allow it to dry out for a few days. The stick will then be ready for use.*

SUPPORTS FOR PAINTING WITH PASTELS

In general, pastels are painted on paper. However, this is more a custom than a technical imposition as any material can be painted with this medium. Although the majority of exercises suggested in this book are designed for paper, it is worth considering other supports which can giving attractive results and offer the same reliability as traditional supports.

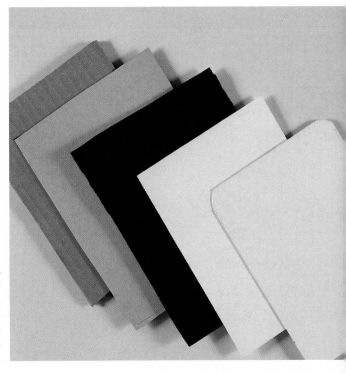

Painting on cardboard. Cardboard is cheap, if you have to pay for it at all, like when it is old packaging boxes. All beginners will have at sometime thrown away old wavy or eggcarton style cardboard with its very porous and absorbent surface which means that pastel adapts to it perfectly. Moreover, the thickness and color of some cardboards make them especially attractive for luminous pastel colors that stand out due to their purity.

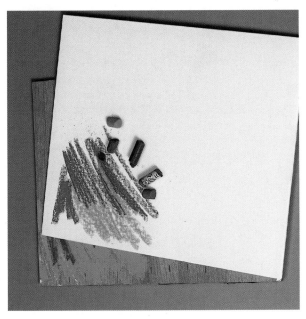

▼ *Painting on top of wood and stiff cardboard.*
Wood is an ideal surface to paint on. The advantage of this type of support is its rigidity and its special texture. Stiff cardboard is another support well suited for pastel painting. It can be bought in fine arts shops, where it is also known as pastel-card. There is a great range of sizes available.

▼ *Primed canvases. Fine arts shops offer a great variety of canvases primed for painting. They are sold by the centimeter and come mounted on a stretcher. To paint with pastels, it is better to buy the cloth loose and to use it as if it were paper. To paint on top of fabric or paper, you need to have a board, drawing pins, and pegs or sticky tape.*

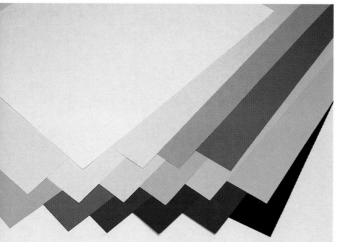

THE SUPPORT: PAPER

Pastel is an opaque and dry medium, the properties of which allow it to be painted on a wide range of supports, but without doubt, it is paper which brings out the best in it. Any type of paper can be used with pastel, although those specially designed for pastels enhance the beauty of the colors, offering the artist the surface needed for a particular style.

▼ *Colored papers. These are the most commonly used papers for pastels. The most renowned manufacturers have a wide variety of papers, in all colors and tones. To start with, buy some earth or tobacco colored papers before moving onto bolder, more daring ones. As will be shown later, the color of the paper plays a key role in the way the picture develops since it forms part of the color range used.*

▼

Watercolor paper. Watercolor paper, available in many different varieties, is also suitable for pastel painting because it is absorbent. Medium-to-heavy grained papers give the best results.

▼ *A pad of drawing paper. A useful material to do color tests and sketches.*

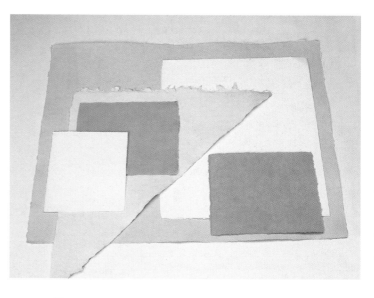

◄

Handmade paper. Its texture is irregular so any work done on it will incorporate its unique surface characteristics. In theory, they are not the most suitable papers for a beginner, although it is not a bad idea to try them out from time to time. In this picture you can see unusual and irregular paper shapes.

THE GRAIN OF THE PAPER

As painting in pastel is so direct, the characteristics of the support are fundamental to the way the painting develops, and, of course, to the end result. Paper is not only classified according to its color but also according to its texture, which is determined by the way the paper is treated when it is still in the form of soft paste in the manufacturing process. If paper is pressed on a very marked sieve, this will be noticeable in its texture.

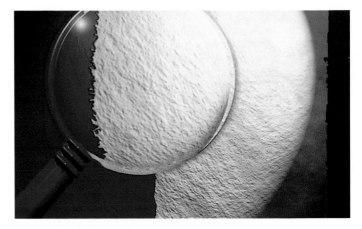

▼ The grain of handmade paper comes into its own if it is utilized correctly. Pastel can be applied almost like a paste and an extensive range of effects in which the paper grain plays a role are possible.

Besides handmade paper it is also possible to buy coar grained paper, which are more economical than the former. However, the stroke effects will not be as marked, as we will see in the corresponding section, but rather highly expressive effects can be achieved.
▲

▼ In general, commercially manufactured paper for art work has two different textures, one on each side. The smoothest texture allows the pastel stroke to mark the style. On this side of the paper it is possible to draw perfectly without the paper grain pattern standing out (above, on the left). If you turn the paper over you will observe that the texture changes significantly: the paper acquires a uniform roughness through which the grain of the paper can be seen (on the right). This surface is better for pastel painting because not only does the pastel stick respond to the paper but also the texture contributes to the stroke and shading effects.

Materials

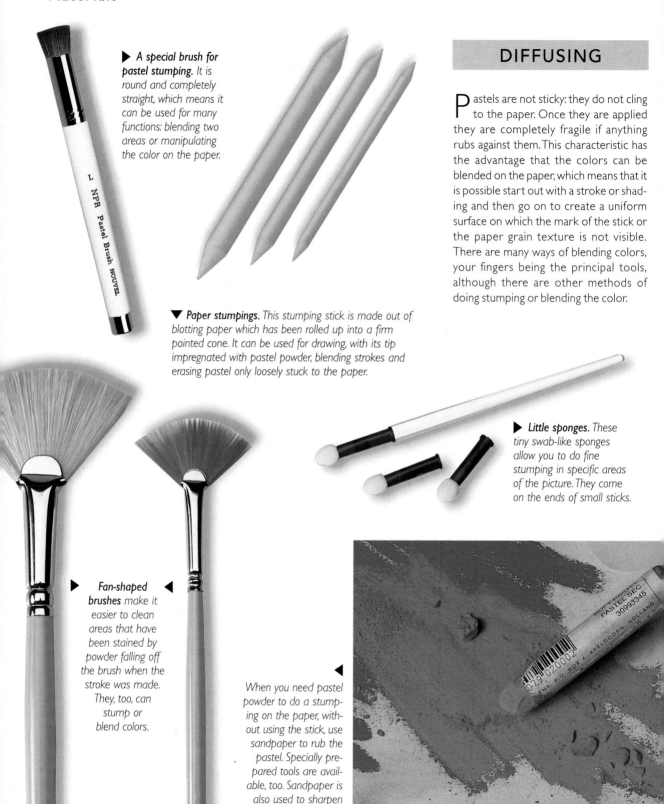

▶ *A special brush for pastel stumping.* It is round and completely straight, which means it can be used for many functions: blending two areas or manipulating the color on the paper.

▼ *Paper stumpings.* This stumping stick is made out of blotting paper which has been rolled up into a firm pointed cone. It can be used for drawing, with its tip impregnated with pastel powder, blending strokes and erasing pastel only loosely stuck to the paper.

DIFFUSING

Pastels are not sticky: they do not cling to the paper. Once they are applied they are completely fragile if anything rubs against them. This characteristic has the advantage that the colors can be blended on the paper, which means that it is possible start out with a stroke or shading and then go on to create a uniform surface on which the mark of the stick or the paper grain texture is not visible. There are many ways of blending colors, your fingers being the principal tools, although there are other methods of doing stumping or blending the color.

▶ *Little sponges.* These tiny swab-like sponges allow you to do fine stumping in specific areas of the picture. They come on the ends of small sticks.

▶ *Fan-shaped brushes* ◀ make it easier to clean areas that have been stained by powder falling off the brush when the stroke was made. They, too, can stump or blend colors.

◀ When you need pastel powder to do a stumping on the paper, without using the stick, use sandpaper to rub the pastel. Specially prepared tools are available, too. Sandpaper is also used to sharpen edges or crayon tips.

FIXATIVE

As pastel is a dry medium which gives very pure colors, it is very unstable when touched. Therefore, the painting process is very delicate. As a general rule, it is advisable not to use fixatives on pastel paintings, although there are spray fixatives that, when used correctly, allow the painting to be conserved, at least in the first stages of the picture, so that you can make corrections without fear of losing what you have done. One must remember that a fixative has serious disadvantages when it is applied to pastels. Therefore use it carefully.

There are a great variety of products that enable you to fix pastel. Only some of them are shown here. The principal painting brands offer high quality products. When you are buying these aerosols remember to avoid products harmful to the environment and the atmosphere. Normally the chemical specifications are written on the label.

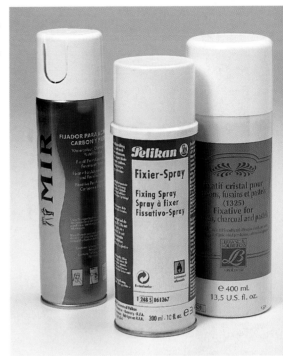

Observe the differences between the end result with fixative and without. In the first case the freshness and spontaneity of the stroke can be appreciated. On the side where fixative has been applied the paint has become stodgy and impasted. This is a clear example of how fixative is not to be used.

Fixative must never be applied to the finished painting because it would darken the colors, ruin the freshness of the pastel and make it stodgy. However, it can be applied at any moment during the painting process, provided that the stage in question has been finished. For example, the layout can be fixed when it has been perfectly defined. Once the fixative has been applied any alteration produced by the colors, or rubbing them out, will not effect the fixed layer. The spray fixative must be applied from about 30 c.m. away. A soft covering is sufficient to make the color stable on the paper.

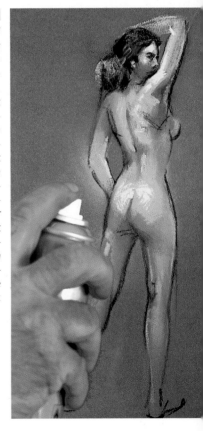

FRAMING AND STORING THE WORK

A s we have seen in the previous sections, pastel is a fascinating painting medium, opening up as many possibilities as any other method. Although a pastel painting stands out for being especially fragile, it can last if it is framed and stored correctly. If due care is not taken, it is possible that the work will deteriorate quickly.

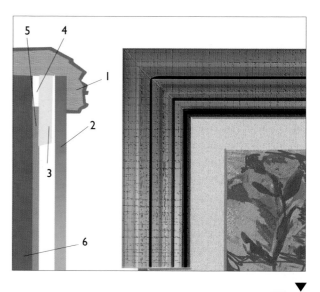

▼ When you finish a pastel painting it will be fresh, which means that any contact with the surface of the paper will leave marks. This is not to say that a pastel cannot stand the test of time. In fact, pastel is one of the longest lasting painting media provided that it is kept in the correct conditions. To store a pastel painting temporarily, place it in a file between two sheets of onionskin paper, or at least clean paper that will protect the surface of the painting. When stored, pastels should not be subjected to jerky movements which could cause the surface to be rubbed. If they are going to be packed away for a long period, put a little bag of drying agent so as to avoid mildew.

In these diagrams you can see how a pastel painting must be framed. The paper must never touch the crystal or glass surface. A special cardboard, called a passe-partout, is placed between the crystal and the pastel, enabling the picture to be framed perfectly. Art shops sell a great range of sizes and colors of passe-partout. They can be adapted to many formats. However, if you needed a special shape a picture frame shop will build one made-to-measure. The pastel must be mounted on a support to avoid it moving within the frame. A ph neutral adhesive is advisable so as not to harm the paper. Frame (1), crystal (2), passe-partout (3), air chamber (4), pastel (5), and plywood background (6).

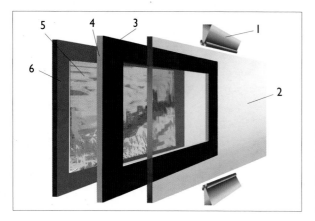

▶ The simplest and cheapest option is to frame the work with special clips. However, even in this case there must be a passe-partout for the crystal or plastic must not touch the paper. Clips (1), crystal (2), passe-partout (3), air chamber (4), and plywood background (5).

Strokes and marks

OPENING STROKES

This first exercise deals with the first pastel strokes. As can be seen, all the edges and sides of the pastel can be used to draw lines as fine, or as thick as the stick itself, and from this base you can go on to explore pastel techniques.

Pastel is both a painting and a drawing medium that allows you to employ a wide range of effects. In this first topic we are going to delve into the elementary concepts of this marvellous technique. As will be discovered through the different topics of this book, pastel technique can be learned progressively. It is worthwhile for the beginner to work carefully through the exercises proposed and through the different points dealt with in every topic.

1. *It would be absurd to use a pencil or charcoal to do the layout of a piece that is going to be made in pastel. A pastel stick leaves a clean mark on the paper: you do not need to fall back on any other drawing media. As pastel paints with its entire surface, its strokes are similar to those of charcoal, although it is true that pastel is more stable, less prone to crumbling. This property is no set back, especially if the picture is going to be covered in color. The opaque quality of the pastel colors makes it possibleto use all types of strokes and corrections.*

2. *In the other drawing media the amount of paint loaded on to the brush determines the color intensity, but this is impossible with pastels. Strokes can be done with the stick, crosswise or vertically, but the pastel cannot be spread as if it were a liquid method. Use strokes to build the surface of the painting. These can be closer together or far apart, and they can be wide or narrow like the tip of the stick. Whatever way they are done, even with the pastel stub, the picture is made up of strokes.*

▲ 1. *Holding the pastel stick flat when you make the first strokes gives versatility. As can be seen, the strokes do not have to be straight. With a pastel stub stripped of the paper wraper, work with the pastel flat between the fingers. Its shape favors the width of the stroke: the petals are soon covered. If you gently turn the stub, without standing the pastel upright, the thick stroke becomes a fine line. You can now work lengthwise.*

FINE LINES AND TRUNCATED STROKES

Many different strokes can be made with pastel. So much so that the artist should start practicing with the different stroke possibilities before going on to develop different colors. Throughout the exercises presented you will be able to appreciate that strokes are often employed as simple lines, or as shadings which are cut short by a twist of the wrist. This exercise is about painting a flower. Pay a great deal of attention to the strokes in the different areas.

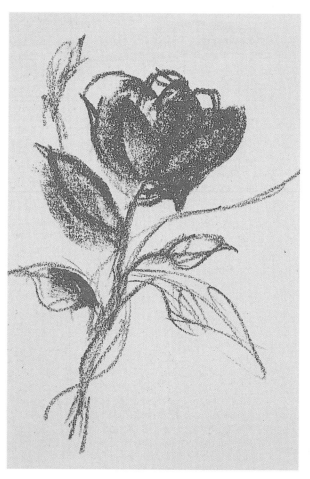

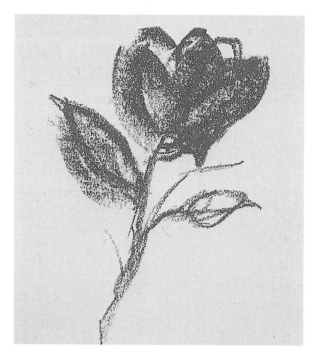

▼ 2. *When the pastel is held upright the quality of the stroke is very different. It becomes a fine line and responds to the delicate movements of the wrist and fingers. This can be seen in the flower stem exercise, where the leaf on the right has been drawn in a very loose, free way, without being too rigorous in the development.*

▼ 3. *Strokes made with the pastel held flat can vary both in intensity and in pressure. The granulation reflected in the stroke as it is dragged depends on the paper, the texture, and also on the pressure applied. Some areas seem to have a denser color because the pastel has been pressed harder onto the paper.*

DRAWING WITH THE PASTEL FLAT AND WITH THE TIP

Although many different ways of drawing are possible with the pastel stick, basically it comes down to a choice between holding it upright, thus giving a gestural line, or holding it flat and therefore rapidly covering wide areas of the paper. In this exercise we are going to experiment with the different possibilities.

1. *To do the sky in this picture use a pastel stub held flat between the fingers but do not press down very hard so that the whiteness of the paper is not completely blocked out. The blue area should be covered, while the outlines of the clouds are left unshaded. This is called reserving an area: it is the stain that outlines the white and gives it shape. The lower part is also painted with the pastel flat between the fingers, but now the stroke is lengthwise. Drawing like this enables the layout to be done quickly and ensure that it will turn out as planned.*

2. *This phase of the drawing is carried out with a flat stick to give a crosswise stroke, the best way of going about the landscape. You can now work with a much firmer stroke. Where you are seeking a greater contrast, insist more intensely. In the areas that are going to have a softer tone use a flat stroke, pressing down very lightly on the paper.*

Pay attention to the effect of superimposing the layers on top of one another, and to how the stroke can be more or less opaque.

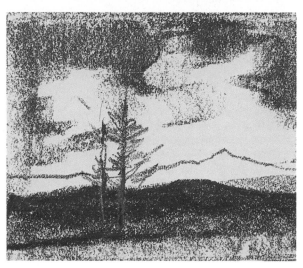

3. *Once the layout of the landscape base has been completed, fresh touches that finish off the details can be added. It is only logical that the final strokes are much more descriptive than the beginning ones for they show the delicate profile of the mountain in the background, or the tree in the foreground.*

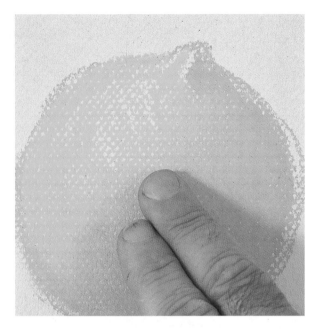

BLENDING COLORS

In the previous exercises we have studied some of the principal applications of pastel. The exercise that we are going to do now includes all of them, and also deals with a new way of working with pastel, blending tones and colors. This is one of the most important effects used in pastel technique.

▶ 1. *In this exercise we are going to paint a piece of fruit. Firstly, an orange shape is sketched with the pastel. Then the inside is colored with a golden yellow cadmium. On top of the yellow, paint in orange, dividing the fruit into two distinct parts. Without pressing more than is necessary so that the colors do not mix, gently rub over the right area until it is uniformly covered with the tone. When the fingers come to where the two colors meet, rub softly until they subtly merge together.*

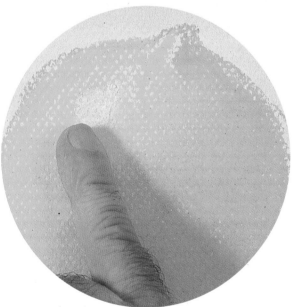

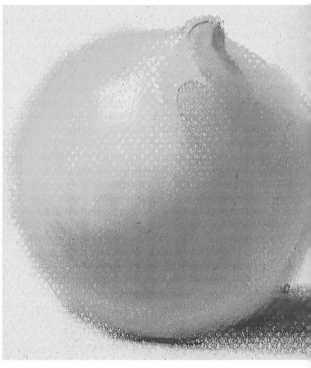

▼ 2. *This stage is especially interesting for we can see how the blending of one color over another does not have to take in the entire surface. All that has to be done is to gently pass the finger over a light area without touching the upper part. This is an example of how the pastel retains its freshness.*

▼ 3. *As many layers as are necessary can be superimposed provided that the colors are not mixed on top of each other. Take great care when you blend in the contours of the new tone. On one side the color is spread with a finger until it completely covers the contour of the fruit. Around the luminous area do a rough merging so that no fingerprint traces are left.*

Step by step
A still life

Pastel is an ideal medium for translating what may begin as a mere thumb-nail sketch, into a full-blown painting. In this exercise we are going to use pastel with quite simple techniques. It is not fundamental that the result be identical to what is shown in the images. This will be achieved later, with practice. It is important that every step is followed carefully, making it easier to achieve a satisfactory result.

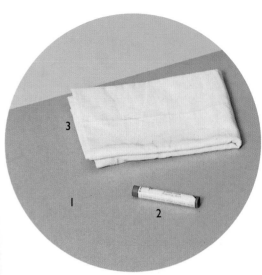

MATERIALS

Color paper (1), pastel stick (2), and a rag (3).

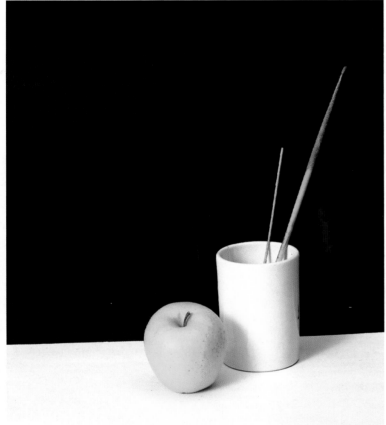

When you are painting in pastel, as it is a fresh medium, you must always be careful to avoid rubbing the hand against the paper.

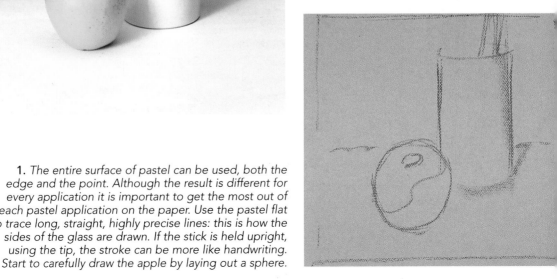

1. The entire surface of pastel can be used, both the edge and the point. Although the result is different for every application it is important to get the most out of each pastel application on the paper. Use the pastel flat to trace long, straight, highly precise lines: this is how the sides of the glass are drawn. If the stick is held upright, using the tip, the stroke can be more like handwriting. Start to carefully draw the apple by laying out a sphere.

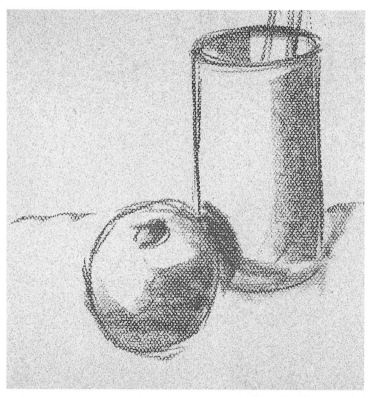

2. *The beginner must get used to working with stubs because pastel is fragile and breaks easily. It is more straightforward and stable to work with a little bit of pastel than with the whole stick. Break the stick in two and then, holding it flat, you can start to do a side stroke. To avoid blocking up the grain of the paper, do not press too hard. The jar is drawn with one vertical line. The apple stroke is done with a twist in the wrist. Once again, the pastel is flat between the fingers.*

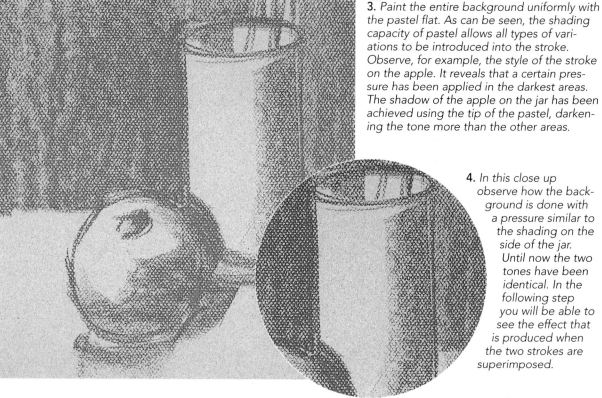

3. *Paint the entire background uniformly with the pastel flat. As can be seen, the shading capacity of pastel allows all types of variations to be introduced into the stroke. Observe, for example, the style of the stroke on the apple. It reveals that a certain pressure has been applied in the darkest areas. The shadow of the apple on the jar has been achieved using the tip of the pastel, darkening the tone more than the other areas.*

4. *In this close up observe how the background is done with a pressure similar to the shading on the side of the jar. Until now the two tones have been identical. In the following step you will be able to see the effect that is produced when the two strokes are superimposed.*

5. *Passing the pastel twice over an already painted area enables the tone to be darkened. This time, to get the darkness of the glass right, use the tip of the stick. This has a strong darkening effect and at the same time enables you to closely control the forms as you draw.*

If you do not exert too much pressure when painting, pastel can be removed with an eraser, or flicked off with a rag.

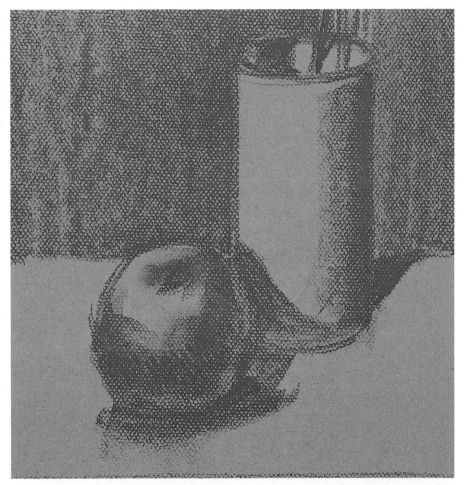

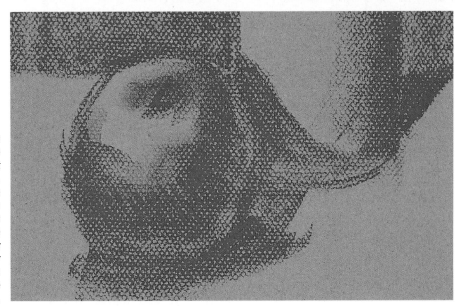

6. *Once the first strokes have been laid down on the paper you can start to paint in the deepest contrasts. Paint the apple with the tip of the stick, which offers a direct and spontaneous style. The hardness of the stroke allows the shadow areas to be made darker and denser. As pastel is an unstable medium, it can be blended with the fingers.*

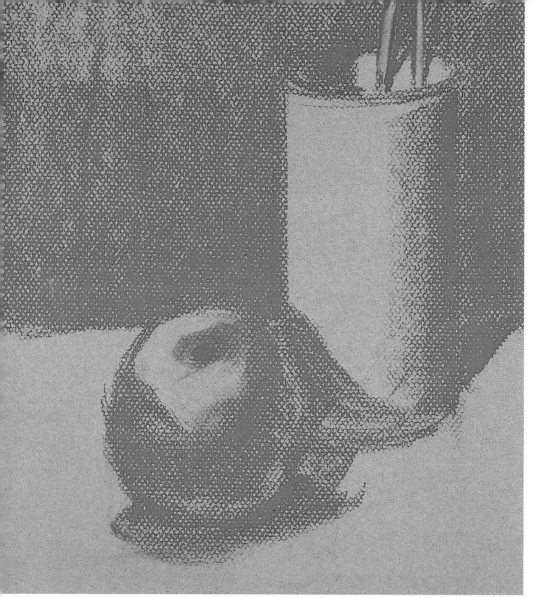

7. *To finish off this exercise, darken the background by going over it again with side strokes. Once these dark areas have been put in, they finish off the contrasting of the unpainted luminous tones.*

SUMMARY

The strokes that are drawn crosswise with the side of the stick allow areas to be covered with thick lines in an even texture.

When **the tip of the stick** is used, it enables you to draw in a gestural style. This is how the outline of the apple has been done.

The flat, lengthwise stroke helps you to do firm, straight lines.

Superimposing strokes on top of each other enables the paper pores to be covered.

Initial layout

DRAWING WITH PASTEL

When the pastel technique is explored for the first time what stands out is the possibility that this medium offers for working with the strokes on the paper. On one hand, you can draw perfectly, as if it were a pencil. Alternatively, the colors can be superimposed, both with the tip of the pastel or with it flat between the fingers.

In the pastel technique the way the stick is held and applied to the paper is very similar to any other drawing media, like charcoal or sanguine. Pastel is not a drawing medium, although it can be used as such. It is a method of painting. In the light of its properties, the approach to it must be fresh and spontaneous. Therefore, whatever happens, avoid mixing the colors to get other colors. Art supply shops will have the exact pastel tint you require.

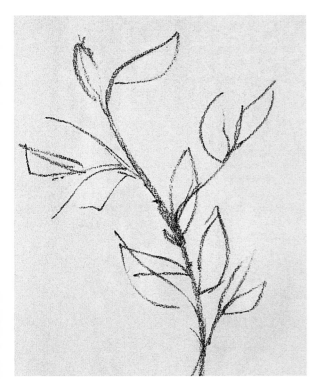

▼ The powdery texture of pastel allows the artist to draw, to shade, and to rub out like any other drawing media. All types of strokes can be erased with a simple flick of a cloth or the hand. This is why doing the layout for the drawing is not difficult: the technique permits on-going corrections to be made. The cloth should be made of cotton and clean so that it does not dirty the other colors.

▼ The pastel allows the layout to be made with a clean and direct stroke, the exact definition of which depends on the way it is used. As the pastel can paint with all its surfaces, the strokes achieved are similar to those of charcoal, both by painting with the pastel flat or by using the tip of the pastel. At the same time the opaqueness of the pastel colors allows any stroke or correction to be covered over.

Just passing the pastel over the paper surface is sufficient to do a line. If you pressed the pastel stick too hard against the paper either you would break the pastel or just clog the support up with too much color, which is totally unnecessary in the early stages.

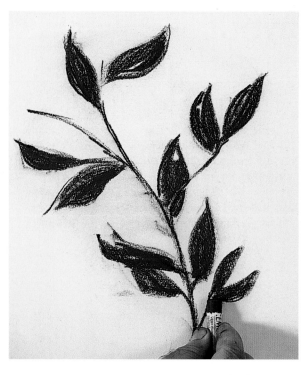

BUILDING UP THE PICTURE

In pastel painting, the work has to be done progressively. This in part is due to the opaqueness of the method, and, secondly, because it is possibe to correct as you go along. This is clearly demonstrated in this exercise. On the previous page we looked at how to arrange the layout and how easy it was to correct it. Now, starting out from these barely insinuated lines, go over the forms with a firmer stroke. This is called restating.

▶ **1.** *The painting of the picture is based on lines. These can be joined together or separated, and be as wide as the tip of the pastel or the pastel stub, whichever is being used. To quickly color each and every one of the leaves that have just been drawn, use a dark green. The lines are still visible during this process. This is one of the characteristics of pastel painting.*

▶ **2.** *Pastel does not need drying time so it is not necessary to wait before painting a fresh color. This is a property that gives it great expressivity. Some other painting media do not permit certain layering of color unless the underpainting has dried. As can be seen in this sequence, it is possible to paint a lighter color on top of a darker color without it becoming transparent or mixing with the color underneath. On top of the dark color, paint the most luminous area of each leaf in a bright green.*

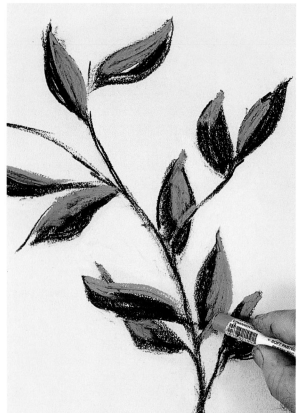

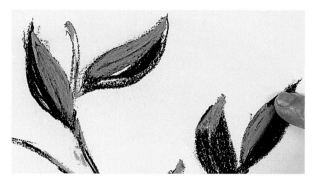

▼

3. *Just running a finger along the dividing line between two colors is enough to blend the strokes together. Do not rub so much that the colors mix. Gently rub where they meet to blend their edges together.*

COMPOSITION

We have studied how pastel painting is started with an initial layout, and how very simple elements like leaves are elaborated. These are some of the most elementary effects. The last exercise showed how the initial layout must be done carefully and precisely. If the elements are simple and do not require a marked structure to develop them, a drawing like the ones on the previous pages is enough. However, this exercise only aimed at practicing the stroke and constructing the forms. When the model is more complicated it is necessary to do a plan before going on to sketch the painting.

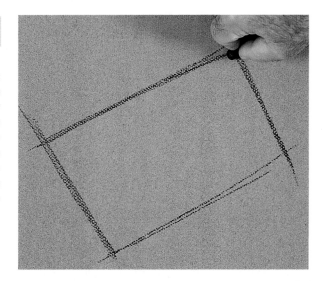

▼

1. *The layout is done on the drawing paper. Within this plan the most elementary forms are developed. The aim is to see the unity of the composition, as if it were just one object. This example is a simple still life of two lemons. Doing a layout will add realism to the picture: if you start with a general plan of a few lines it is much easier to place them in the picture. The internal forms have not been put in yet. First, we have to get the box shape, in which they will later be fitted.*

> It is advisable to do the layout of the forms with the pastel stick flat and using a lengthwise stroke.

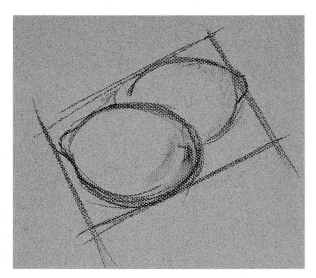

▼ 2. *Inside this very simple form, the basic shape of the lemons can be more fully sketched. When drawing them, their relative sizes and forms must be considered: the initial layout has to be respected. In this step and in the previous one, we have first done a straight line layout, then we divided it and went on to do more descriptive drawing.*

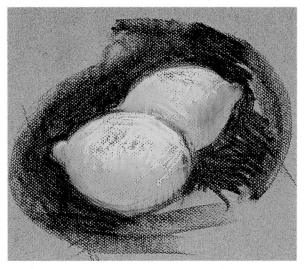

▼ 3. *By now the forms of the lemons are perfectly defined. At the start of this chapter we saw how pastel could be corrected easily. In this exercise it is not necessary to rub out the lines of the layout: you can paint directly on top since the new color will cover them completely. As can be seen, the layout is very important to ensure that the picture evolves smoothly.*

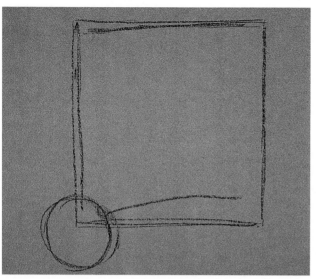

WORKING OUT THE COMPOSITION

When the forms of the model are even more complicated, you must be able to fall back on a more thorough layout. The most difficult forms to do are the symmetrical ones, and shapes that are nearly pure geometric figures. In fact, it is much more complex to do a simple white plate than to do a very exotic flower or a stormy sky. Whenever you have to do a geometric object, it is best to do a well-structured layout.

▶ 1. *This could appear to be a very simple exercise as "all" that we are going to paint is a plain teapot and a flower. In fact, it is more complicated than it seems because the teapot has very precise forms in which every line of its structure has to be perfectly balanced with the overall image. In contrast, the flower does not have to be developed so accurately. First, do a layout of all the forms. The sketch of the teapot must have simple lines that make a square. The flower lying on the table can be sketched as a circle, and the stem as a simple line.*

▶ 2. *Even though we do not yet have sufficient visual references to do all the teapot, the initial drawing of the flower is finished. Inside the square form that has just been outlined, a cross is drawn, centered in the middle of it: it will be the symmetrical axis of the definitive drawing. Using this axis, outline the spherical form of the teapot. The vertical axis is used to establish both the center of the lid and of the base. The horizontal axis is a reference point to position the spout.*

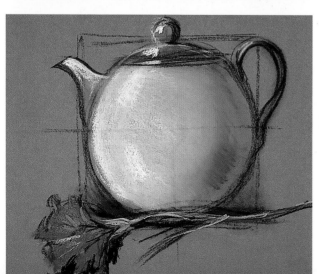

▶ 3. *The drawing is now finished off. Without the initial layout structured into different parts it would have been difficult to develop the form of the teapot. However, to do the flower just a few strokes are necessary.*

Step by step
A still life

Pastel is not only one of the most complete painting methods that exists, it is also the medium which most resembles drawing. It is fundamental to learn to use all of the strokes and marks possible. In this exercise we are going to try out these possibilities with one color only, creating a monochrome, while studying still life composition. In future exercises we will include all the colors that this medium offers. Pay special attention to the simple forms for they help us to tackle the more complicate and elaborate forms.

MATERIALS

Burnt umber pastel (1), white paper (2), and a rag (3).

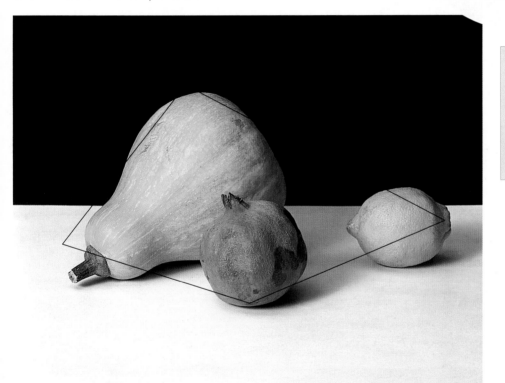

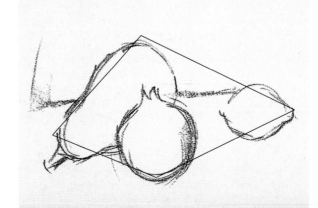

1. *All drawings must be started with a carefully worked out layout. This will be the base on which all pastel pieces will be developed. However complicated a painting may appear, it is always based on simple, well-structured forms. Use the tip of the stick to do the layout.*

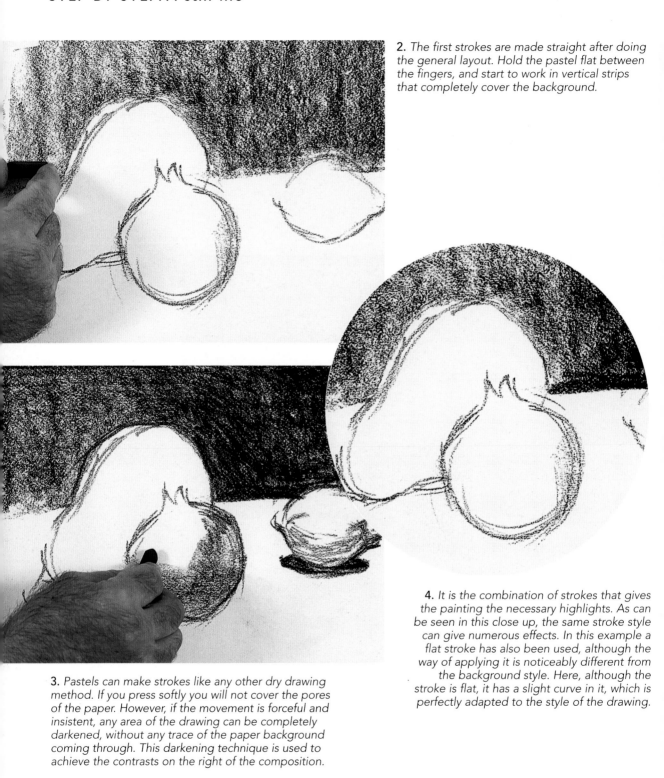

2. *The first strokes are made straight after doing the general layout. Hold the pastel flat between the fingers, and start to work in vertical strips that completely cover the background.*

3. Pastels can make strokes like any other dry drawing method. If you press softly you will not cover the pores of the paper. However, if the movement is forceful and insistent, any area of the drawing can be completely darkened, without any trace of the paper background coming through. This darkening technique is used to achieve the contrasts on the right of the composition.

4. It is the combination of strokes that gives the painting the necessary highlights. As can be seen in this close up, the same stroke style can give numerous effects. In this example a flat stroke has also been used, although the way of applying it is noticeably different from the background style. Here, although the stroke is flat, it has a slight curve in it, which is perfectly adapted to the style of the drawing.

5. *As we have seen in different exercises, using the pastel flat can give a great variety of effects. Depending on the stroke, in some areas the pores of the paper will be completely covered by the pastel, and in other areas the stroke will be adapted to the design of the form. Use a flat stroke to shade the pumpkin. Go around the shape applying minimum pressure so as not to block up the pores of the paper. On top of this stroke do the furrows with the tip of the stick.*

Soft pastels are especially suitable for pieces which need shading. Although, they crumble very easily, do not throw away the little stubs because they can be used to paint little descriptive details.

6. *When you want to darken a previously shaded area, another pastel addition is made. The shade of darkness that is achieved will depend on the type of stroke used. In the background the still life forms are restated, but this time on the left where the stroke was much weaker.*

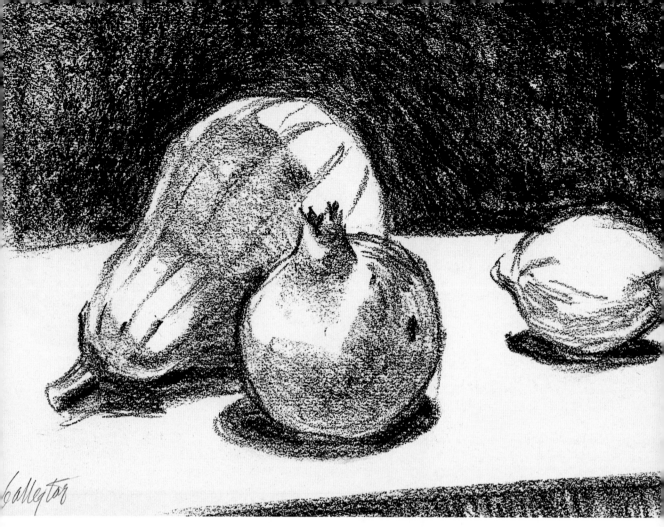

7. *To complete the exercise, all that remains to be done are some final strokes in the lower part of the composition using the tip of the stick. Throughout this exercise we have seen how different stroke styles can be applied, and how the layout is developed. This same technique can be useful in any of the exercises that are presented in the following topics.*

SUMMARY

Pastel can paint with its entire surface. The stick is used flat to color the background; the strokes are vertical.

The stroke obtained with the tip of the stick helps to draw lines and fine marks, in the same way as if one were drawing with a pencil.

Superimposing strokes on top of one another produces dark areas. If you press down hard enough, the pores of the paper will be covered completely.

If a low pressure stroke is made, the paper grain shows through. The areas in which the texture is noticeable were gone over very gently.

Surfaces and mixed techniques

THE ROLE OF THE PAPER

It is the grain which gives paper its texture. In the following exercises we will practice on different grains of paper. The first exercise is very interesting because it enables us to learn about the stroke effects on different grains of paper.

Pastel can be painted on any surface and with many different methods. Good results are obtained by mastering the technique and understanding the surface on which you are working. In this chapter we are going to study different aspects of the technique, from drawing on different surfaces through to the realisation of one of the most interesting mixed techniques that can be tackled: pastel and oil together.

This tree has been painted on thick-grained paper. In this example the paper is especially designed for watercolor and has a very marked grain. When the pastel is passed over the textured surface, the shading reveals the roughness of the paper.

▼ Medium-grained paper is heavily used by enthusiasts of this technique. This exercise consists of doing a simple tree. On this type of grain any stroke is possible, from a fine line, through which the grain of the paper is seen, to a compact stroke that covers the background completely.

▶ Fine-grained paper allows you to do a completely homogeneous stroke, without any texture at all. Nevertheless, it is advisable not to use the first paper you come across. The best papers have a slight stucco texture and are a little abrasive when the pastel is applied. Compare the result of this exercise with the other two on this page to see the differences.

▶ 1. *As was seen in the last exercise, the paper always plays a key role especially as is the case here, when there is hardly any grain. The preliminary sketch is always fundamental, for setting out the principal color areas. When finegrained paper is used the texture of the painting, or drawing, will be minimal.*

FINE-GRAINED PAPER

Pastel is a technique that offers great spontaneous contrasts. As no drying time is necessary, the results of the contrasts can be checked immediately. Landscapes are especially suitable themes because the effects can be used to explore a wide range of possibilities, from direct strokes through to blending and tone modeling. The grain of the paper will be reflected in the texture. In this exercise, use fine-grained paper. Alternatively, the other side of the textured pastel paper could be employed.

▶ 2. *The sky is painted blue and the clouds white, blending the tones with the fingers before adding a new tone on top of the white of the clouds. This time the blending is low key, just enough to soften the impact of the stroke. In the foreground, a very dark and strong contrast, which clearly defines the different planes, is painted.*

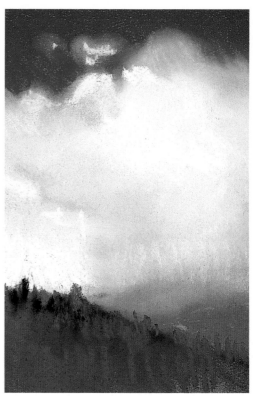

◀

3. *It is not advisable to do all the picture by diffusing and blending. You have to alternate this with the direct application of color, otherwise the painting would turn out to be repetitive and contrived. Finer grained papers are suitable for mixing contrasts and directly applying dashes of color.*

PRACTICING ON DIFFERENT TYPES OF PAPER

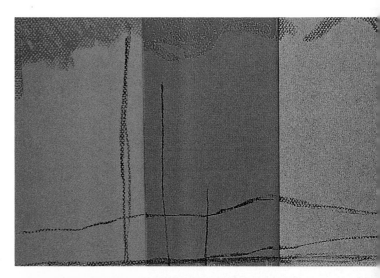

As pastel is a totally opaque method that can be worked on any type of surface, the paper does not have to be white. Paper manufacturers offer a wide range of colors. When practicing daily, the artist chooses the paper color that combines effectively with the pastel tints employed. Here is a simple exercise with three different colored papers which will reveal how pastel responds to different colored backgrounds.

1. Place the three different colored papers side by side and join them with sticky tape: this is going to be the support. The landscape to be painted is dominated by dark colors. A clean stroke will outline the structure of the mountains and the foreground. Paint the sky blue. Each of the different paper colors responds in its own way to the pastel colors.

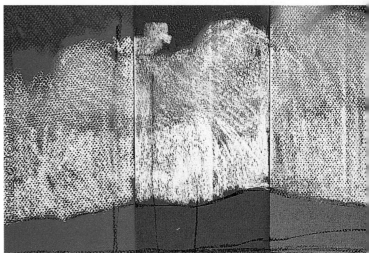

2. Paint the clouds white, but do not press too hard with the stick so as not to cover the grain of the paper. Whether you paint with the stick flat, or with the tip, the background color will show through the stroke. Observe how each of the paper colors responds in a different way to the white lines. The yellow also gives similar results when it is used to paint the ground base.

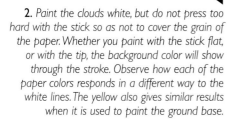

Always try to use top quality papers for painting. Cheap cardboard and other substitutes will fade as time goes by.

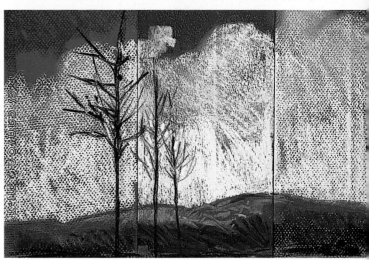

3. The chromatic response of each of the different paper colors varies when the pastel is applied. In the same way that the color of the paper is visible through the strokes, a color layer can show through new pastel strokes put down on top.

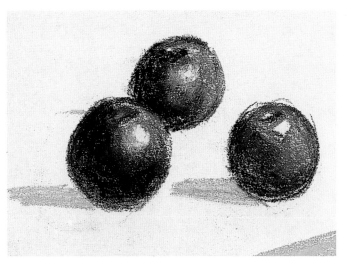

▼ 1. *Just like all other pastel techniques, when you paint on canvas the results depend on the way the different types of strokes are combined. However, as you will see, on canvas the pastel colors become much more compact since the primed canvas texture is far more abrasive than paper. Moreover, the pores of the latter also allow more color to be used.*

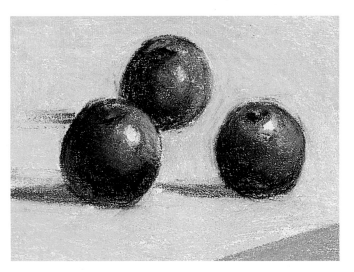

▼ 2. *When you paint with oil pastels the paint can become so compact that it creates areas of great density. However, the opaque properties of pastel remain unchanged. In this exercise you can appreciate how the color of the shadows on the table cloth changes.*

PASTEL ON CANVAS

Although pastel can be used on any surface, and it is best suited to paper, many artists use it on canvas. Any type of pastel is suitable for canvas, but oil pastel is the best. Not only does it stick well to the canvas, but it can also be applied with turpentine and brushes, and mixed with oil paints.

▼ *When you paint with oil pastel on canvas, very original effects can be achieved. Oil pastel can be blended on the canvas or on the paper with the aid of a brush dipped in turpentine. This makes the stroke more liquid. These blended areas of the pastel can be contrasted with the areas where the stroke of the pastel remains obvious. As can be seen, pastel opens up many possibilities, although traditionally this method has not been over used.*

Step by step
Flowers in pastel and oil

There are no hidden secrets to the method used in this exercise. The basic rules are very straightforward: paint in pastel and elaborate the rest of the picture with a brush dipped in oil paint and linseed oil. When the colors are mixed the pastel particles blend perfectly with the oil particles producing a new kind of oil-like paint. What is attractive about this technique is that it combines the effect of the pastel stroke with the blending together of the oil brush stroke.

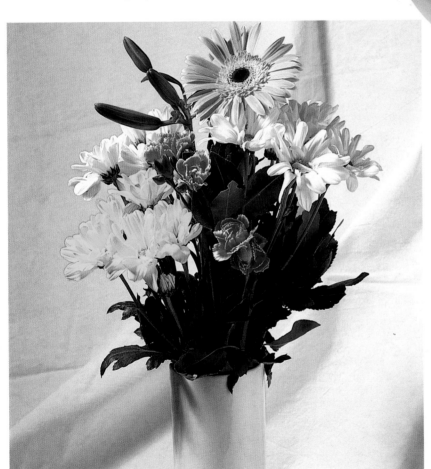

MATERIALS

Pastels (1), oils (2), palette (3), brushes (4), cardboard (5), turpentine (6), linseed oil (7), and a rag (8).

1. Start the painting with a rough sketch done in oil watered down with turpentine. The brush must be almost dry. Do not let the picture become smeared with oil or turpentine, otherwise you will not be able to do unblended pastel strokes. Once the drawing has been done, the first colors can applied. Firstly, paint the rose colored flower with free, direct strokes. Then add the gray spots on the daisies in the shadows. Do the rest of the colors in a very direct style, without going into the concrete details of the flower forms.

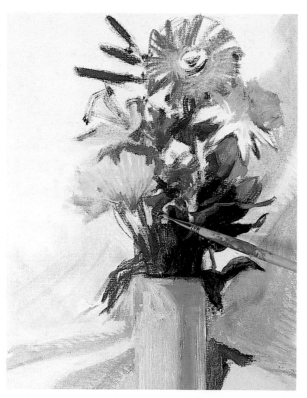

2. *Finish off the outlines of the flowers, the stems and the leaves. Dip the brush lightly in oil and then spread the color of the stems towards the side of the vase. Use the same style to insinuate the form of the vase with simplicity. Use a violet gray pastel to shade in the dark areas on the cloth in the background.*

3. *Wet the brush slightly in turpentine, load on the green paint and then pass it over the form of the stems. Use very fine brush lines initially to give form to the yellow flower. Up to this point, all the early work is done in pastel, except for some minor touches with oil. To give a good base to the oil, the surface has to be as free of grease as possible.*

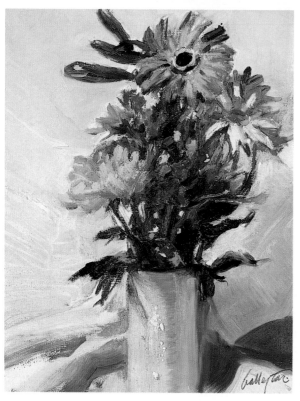

4. *Apply a violet pink tone pastel. This will be the base color for the work in oil. Paint the leaves on the right with olive green oil; the brush strokes are super-imposed on top of the pastel below, but without drag-ging the color. Do the dark parts of the lower stems with violet blue oil paint. The shadows of the leaves and the dark parts of the stems are done in a dark green. Paint white pastel onto the highlight area of the vase, and then mix it with a gray oil color.*

5. *Work on the yellow flower with dashes of pastel and oil. These very direct touches of pastel are applied without any subtlety in the wrist or hand. The brush strokes drag part of the orange color and mix it directly on the support. Paint some dark colored stains on the edge of the petals of the big flower in the middle. In the same way, some gray oil brush strokes are added to the grays of the daisies in the background. Darken the leaves in the upper part with a long oil brush stroke which drags part of the lower color along with it.*

Painting with oil and pastel is not very complicated, but do not forget that not all the areas must be covered in oil. The pastel must show through the strokes that are overlaid on top.

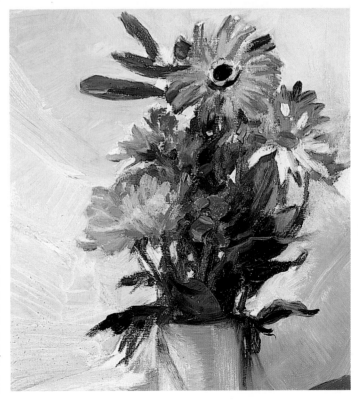

6. *This stage of the work revolves around blending and applying oil on top of the pastel base. Do the flower forms by alternating direct brush strokes with dragging strokes that blend some of the pastel painted beforehand. Dip the brush in oil and then go over the dark parts of the canvas in the background. If they still turn out to be too light, add violet gray pastel powder.*

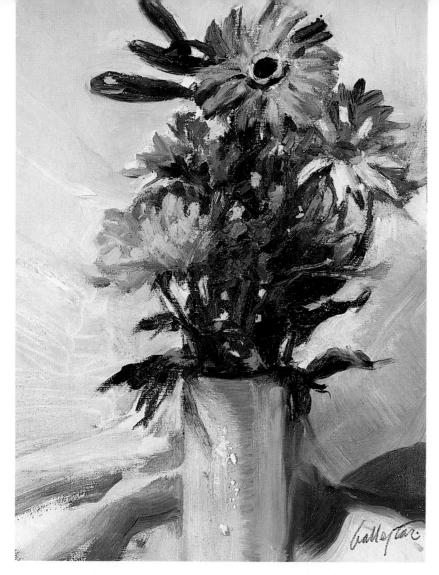

7. *Once the principal oil shadings and blendings have been done, continue insisting with different pastels so as to produce impacting colors in some concrete areas of the flowers. Press hard with the pastel to leave part of the color very luminous. This picture which mixes oil and pastel techniques is now finished.*

SUMMARY

The initial sketch is done with oil diluted with turpentine. The first layers of color in a mixed technique piece like this one always have to be less oily than the subsequent layers.

The canvas background is painted with the brush wetted in turpentine in order to blend the color.

Direct pastel strokes create highlights between the leaves and the stems.

Make the first marks of the picture in pastel and use them as a base to give nuances to the flowers. Pastel adapts perfectly to the canvas. Afterwards it can be blended with the oil paints.

Color ranges

COLOR RANGES

Pastel is a painting as well as a drawing medium. What does this mean? Simply that the way it is used allows the artist to achieve any of the effects found in painting, through the expression of the texture and color. The principal characteristics of pastel are the strong colors and the vitality of each stroke. To help to understand the way the colors work, it is worth noting that pastel colors are not obtained through mixing: you apply them straight out of the box where they are stored.

Whether or not the pastel technique is complicated depends on the way the artist uses it. Being familiar with the materials will allow the beginner to introduce new techniques, and materials, as the necessity to be more expressive grows. As a painting medium, pastel offers a great variety of possibilities, starting from the application of colors and ranges.

▶ *A color range is the harmony between a scale of colors. If you look at the pastel color palette, you can distinguish colors that can be grouped together according to temperature. One range, for example, could be the earth colors, which includes a great variety of tones.*

The pastel color ranges can be very wide, and therefore it is advisable to use specialized ranges for different themes: seaviews, landscapes, portraits, etc.

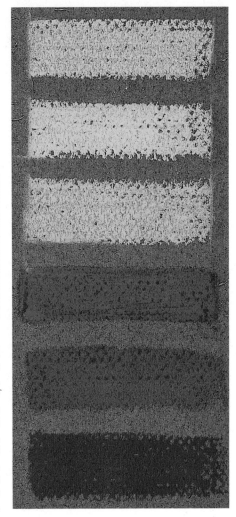

◀

Other color ranges are the so called harmony ranges, which are composed of colors of the same family. For example, the cool colors are all the blues, greens, greeny yellows and violets. At the other end, the warm color range is made up of reds, reddish yellows and oranges.

THE WARM RANGE

As we saw on the previous page, the ranges are made up of groups of colors that are similar to each other in their tonal temperature. Each one of the ranges allows concrete themes to be developed, although it is possible to represent a model specific to any range. If you look at the sky at midday you can appreciate a great variety of cool tones, but they can also be represented by warm colors. In this exercise we are going to practice with different warm colors.

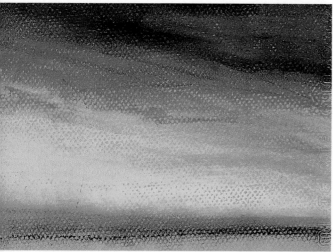

▶ 1. *The color of the paper will influence decisively the colors painted on top. It is important to start out from an initial layout. This can be done in any color. It does not matter if it is lighter or darker than the colors applied afterwards because the opaque characteristic of pastel allows the overlaying of any color. The initial lines will be blocked out by subsequent layers.*

▶ 2. *Start painting the first colors, shading the sky in the background. This step is done with the pastel stick flat between the fingers. The force with which the pastel is pressed will determine if the pores of the paper are closed up or not. All the colors you use in this exercise belong to the warm range. On top of the base color, in the lower part of the sky, apply a red tone which is then blended with the color below.*

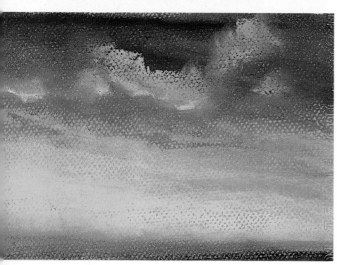

▶ 3. *Use very luminous Naples yellow tones to paint the clouds. This process is not complicated, but it is worth doing with care because the luminous color has to be completely mixed on top of the background. Once the cloud masses have been shaded, gently spread them with the fingers and blend the color into the background. On top of this luminous color, paint with a much lighter one. This new addition will increase the clarity of the clouds. This time the light tones will not blend with the ones underneath.*

THE COOL RANGE

In the last exercise we saw how the warm color range can be used. In this exercise we will focus on some of the cool colors. The blues, greens and some yellows belong to this range. Just as in the last exercise, the objective here is to show how a particular range can be applied. We are going to paint the water surface, working on a very luminous blue color paper.

1. Draw the horizon, which is going to mark the beginning of the gradation, in the upper position of the paper: the focus of attention is the water. Start with a dark blue tone, always using horizontal strokes, and then gradate into a medium blue color. In the foreground, paint in emerald green. So far no color has been blended and in some areas the color of the paper comes through.

2. Gently blend the tones that have been applied. The boundaries between the colors disappear completely, and the stroke-like look fades away into a faint gradation that blends into the background. You do not have to press too hard with the fingers to make the tones blend. Just the slightest pressure is sufficient to achieve the desired effect. Moreover, we do not want to lose the paper's grain.

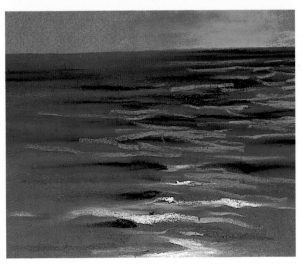

3. On top of the previous tones, paint lighter ones to represent the brightest parts of the waves. Add dark colors to contrast with the background and with the highlights. These last details determine the luminosity and texture of the surface. The highlights are very defined: they are brighter tones which form the chromatic base of the gradation.

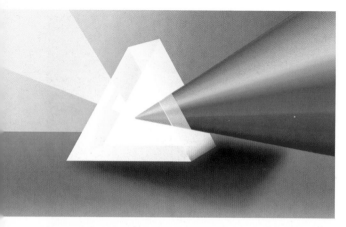

COMPLEMENTARY COLORS

I f a ray of light is passed through a prism, the white light breaks up into a color spectrum. This is how a rainbow is formed by the water droplets. The colors that form the rainbow are the basis for the rest of nature's colors. When painting in pastel, it is not necessary to do mixes because the ranges are already in the box. In this section we are going to study the effects achieved when the colors are used to their full potential.

▼ When a ray of light is refracted, six basic colors, divided into primaries and secondaries, are formed. These are the building blocks for all the colors in nature. The primary colors are yellow, cyan and violet. The secondary colors are green, red and intense blue. The intermediate colors are orange, carmine, violet, ultramarine blue, emerald green and light green. These are the so called tertiary colors.

▶ If these colors are placed in a circle they form the color wheel in which the complementary colors are facing each other.

In this simple exercise we are going to use blue paper. We will paint a flower in its complementary color, red. You will be able to observe how this color stands out on the surface of the paper, while the narrow openings between the red strokes mean that the blue background comes through in a strong contrast.

▲

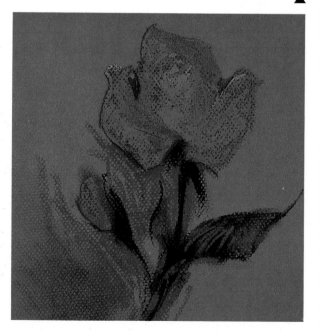

▶ If red paper is chosen, you can work on it with complementary colors. This gives rise to a strong contrasting effect which makes the colors vibrate next to each other. Due to its purity, pastel is a medium that is especially suitable for this type of visual effect.

Step by step
A landscape with cool tones

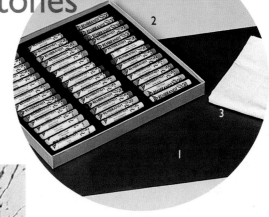

Landscape is one of the most interesting themes that can be developed in all the color ranges. We are going to do a landscape full of nuances and based on the cool color range. In this model you can appreciate the numerous dashes of color from the blue and white ranges. The development could seem a little complicated, but if you observe the images and follow the technical instructions closely, the final result will be positive.

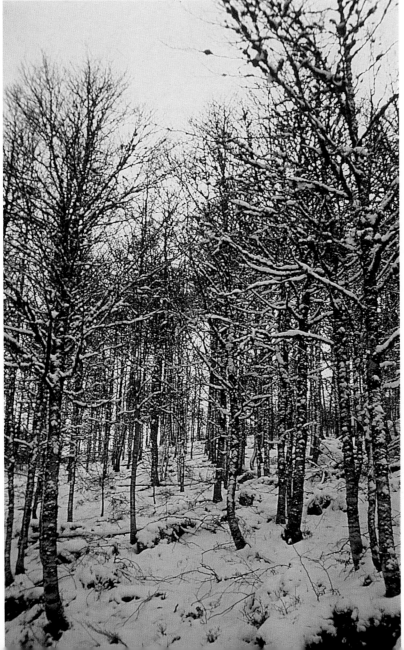

MATERIALS

Tobacco color paper (1), pastels (2), and a rag (3).

1. *The initial layout is sketched in a very light color that stands out strongly against the background. Not all the trees are drawn at this stage as this would be almost impossible. Draw vertical lines to suggest their forms. Paint the lower part, where the ground will be, white and blue with vertical, energetic strokes so that two bands are clearly defined.*

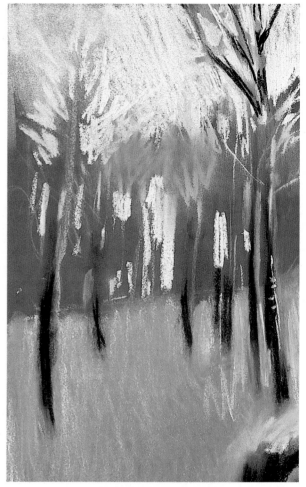

2. *Paint the upper area in an off-white bone-colored tone, using vertical strokes. This will be the part of the sky visible above the bare tree tops. Both the upper and lower areas are blended with the fingertips. The stroke will temporarily become less visible. The first dark parts of some trees are done in black pastel, while the direct, bone-colored strokes form some of the bright areas in the background. The areas of maximum luminosity are painted with white strokes.*

3. *In the upper part, do some more shading with, the bone color, but this time in a much more direct way. Some of the branches of the trees are left unpainted, that is to say, reserved. Paint the background earth green and blend the colors slightly with the fingers. Also, the excessively luminous white of the trees is toned down.*

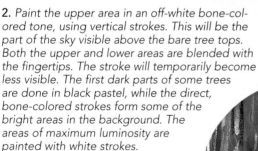

4. *Luminous blue is used for the whole lower part. The color is blended immediately on the background. The tree trunks are reinforced in black and the shadows on the ground are drawn in. This touch perfectly reveals the way the light falls.*

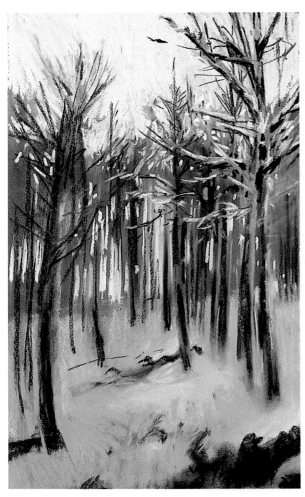

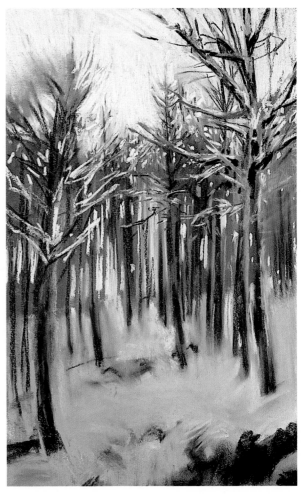

5. *The profusion of bone-colored strokes in the sky allows the unpainted background to come through and interplay with the tree trunks painted in the foreground. To make the trunks seem more realistic it is necessary to paint some intense pastel black contrasts. This step is very important. The cool colors are used directly on the ground, and the strokes are superimposed on top of the already-blended background. If you look closely at the branch area, you will notice that they are superimposed in line strokes over the hazy base.*

6. *Some dashes of Naples yellow are made to vibrate between the branches. This luminous addition means that the blues vibrate more vigorously because of the effect of the complementary contrasts. The outlines of some of the branches in the foreground are restated in black pastel. Add a few touches of blue.*

An effort must be made to use a variety of colors even though you are working with a particular color range. Colors from other ranges strengthen the luminosity of the principal range.

7. *Finishing off this exercise involves quite a lot of work. The details of the trees in the foreground are superimposed on top of those behind. This is exactly where the different contrasts reveal the forms. The highlights correspond to the snow on the branches; they are painted pure white. The contrast formed by the dry part of the tree is painted in black and gray. These tones increase the effect of the luminosity of the snow. Finally, some blue touches add the final nuances to the most distant trees.*

SUMMARY

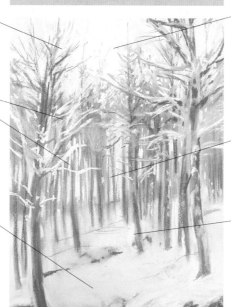

Do **the initial layout** in a very light color that stands out against the background.

The most luminous parts are the snow that hangs on the branches: paint them in pure white.

In the bottom part of the picture lies the ground: it is painted white and blue in vertical strokes that form two clearly defined bands. Afterwards, this plane is blended with the fingers.

A bone color is used to paint the vertical strokes in the sky outlining the tree tops.

The background is painted in earth green. The colors are gently blended with the fingers.

Go over the tree trunks in black and contrast the more dimly lit areas.

Layout and shading

STARTING THE LAYOUT

The layout of any picture is always started with the essential lines, which are indispensable for establishing the basic structure of the picture. For example, if you are going to paint a bunch of flowers, the first lines do not reveal the small details, instead they establish the context and the areas of light and shade. The first lines have to be the basis for later work which will build on the simple and synthetic forms done in the preliminary sketches.

To paint a picture well, it is necessary to begin it correctly. A good initial construction is a perfect base for what follows after, whatever the theme may be. In this chapter we are going to place special emphasis on the construction of the model. It is fundamental to learn the processes that are explained. If these become part of the routine of work, all the rest of the process will be easier and more successful.

▼ I. *Starting out from an initial sketch like this one, which any beginner can easily do, you can draw the lines for the internal structure of the picture. These lines do not have to be definitive. Just as on the clean paper, the initial plan was sketched, now inside this plan the forms of the flowers are laid out. The first form is triangular and inside this shape more precise elements can be included.*

▼ 2. *When the structure of the picture has been defined, the finish will be much more precise. This work process will help the artist to attempt any model, no matter how complicated it may appear. With practice, the first steps of the layout can be omitted, although the image of every step must be born in mind.*

SHADING. WORKING ON THE COLOR

O nce the layout has been completed on the paper, you can start the shading process in the picture. The first thing to do is remove all supplementary lines used to construct the still life. Depending on the method being used for the picture, these lines can be either erased or painted over with other colors.

▶ 1. *Once this first stage has been completed, use a spray fixative. However, bear in mind that if you fix the layout, it cannot be changed later.*

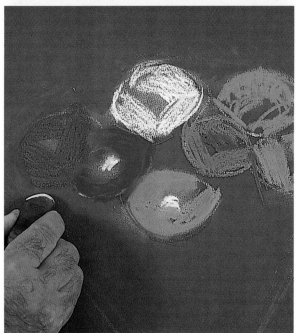

▼ 2. *Pastel has the great quality of blending or of behaving almost like a line drawing. Both these effects must be well controlled from the beginning of the shading process. The areas that have been blended, can then receive new firm strokes. On top of these first marks new lines can be added that define the contrasts. Use an eraser to rub out strokes that overrun the flower contours.*

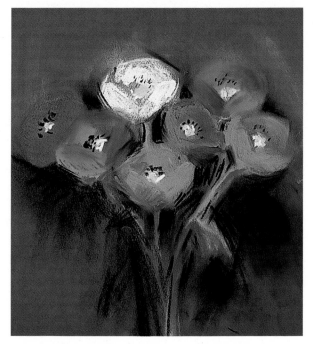

▼ 3. *There is one exception to the no mixing rule. As it is very difficult for the artist to have all the colors on the market, a practical and common trick for the majority of pastelists is to use black to develop tone ranges. Observe the wide range of tones that can be achieved with black as a darkening agent, but, of course, when it blends, the colors below the stroke become less noticeable.*

COLOR NUANCES. THE ABSENCE OF MIXES

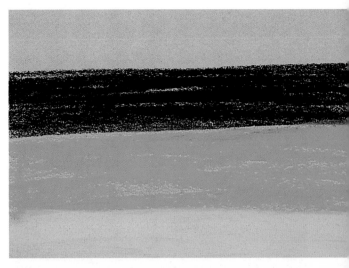

As we have studied so far colors are not mixed in pastels. The artist's palette is what he has in the box. Mixing would just spoil the colors. Having applied the first colors, the artist will go on to need more and more colors to enrich the painting. Although some of the tones may vary slightly, they will give freshness to the picture.

1. In the pastel technique, more than in any other, the color nuance is of fundamental interest. This is a straight-forward exercise in which the importance of different pastel tones can be appreciated. It will be seen that mixes are not necessary to achieve numerous nuances. First, paint with the color that will be the base. In this first layer a gradation of three different tones can be achieved.

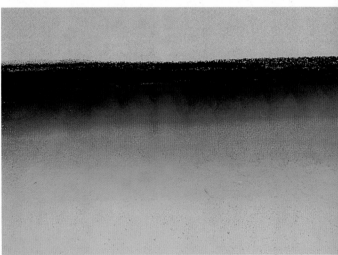

2. Run the fingers gently over the top of the tones to blend the colors together. This is blending, not mixing. It simply allows the definition of a tone base on which direct strokes and nuances will be done. Take care to only soften the edges.

> As it is not possible to have all the colors that are available in pastel, blending colors with black is a good option to establish tones and scales.

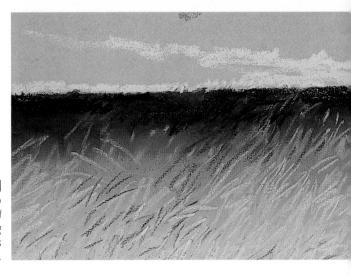

3. The color base allows new tones to be added. This time the tip of the pastel is used so that direct strokes can be superimposed on the underlying gradations. This is one of the most interesting pastel techniques that can be created. As you can see in this example, the different tones distinguish the different planes.

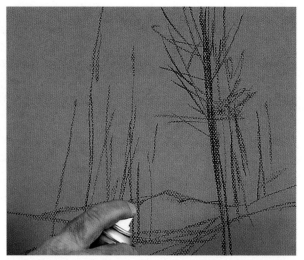

WAYS OF KEEPING THE PICTURE CLEAN

P astel is a medium that is always vulnerable to being rubbed off. Being able to modify a picture also has advantages. However, sometimes this is a drawback: the picture is constantly vulnerable to being smudged accidently. In the early stages of a picture this may not matter much. However, as the painting develops, a mishap can mean that many work hours are lost. To prevent this from happening, several easy measures can be taken.

▶ *One of the most common and surest measures is to fix the pastel at an early stage. A light spray will prevent the first layers from becoming unstuck if they are inadvertently scuffed with the hand or another pastel stick. However, this measure should only be taken in the first painting stages.*

▶ *When you paint with pastel it is quite easy to drag a hand over the picture and spoil the colors. However, preventing this is simple: just put a sheet of clean paper between the picture and your hand. Take simple precautions so that you do not drag this paper across the painting.*

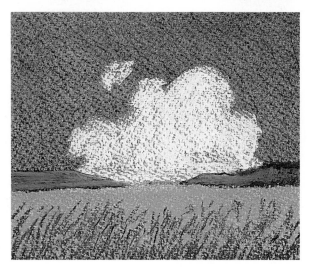

▶ *With the clean paper underneath the hand you can paint resting the hand against the picture without smudging the colored areas. Change the paper as often as is necessary to protect the brightest colors.*

Step by step
Flowers

In any painting technique layout is a fundamental issue. It is curious to think that just a few lines to set out the shape are sufficient as a base for the most elaborate work of art. Pastel, as an opaque painting medium, is suited to doing the picture progressively. Corrections to the layout can be done as you go along, just like color application. In this exercise we are going to do a flower arrangement starting out from the initial sketch.

MATERIALS
Pastels (1), colored paper (2), and a rag (3).

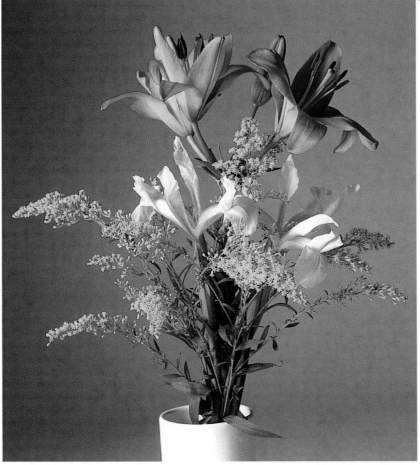

1. *The layout must be structured. Just a few strokes are necessary to do these almost geometric elements. Starting from these forms you can go on to do a much more accurate construction.*

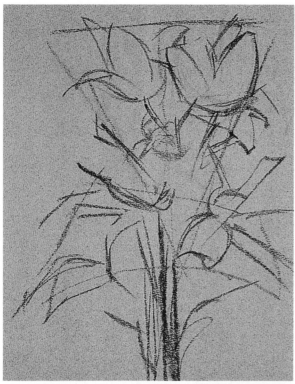

2. *Use the same pastel to further elaborate the layout. The forms are defined much more easily from the strokes of the first plan. It is not necessary to do an exact drawing because the opaque quality of the pastel allows it to be constantly retouched.*

3. *Start painting the background in gray. Outline the forms of the upper flowers and cover over the initial layout lines. Start shading the upper flowers: the darkest petals with orange, and the lightest with a more luminous tone. Use white to give luminous tones to the flowers in the middle, but do not cover the paper completely.*

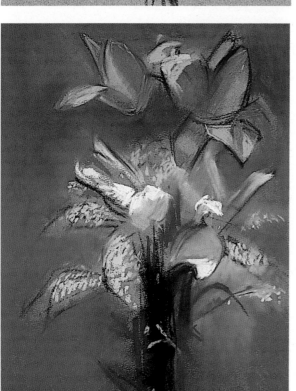

4. *The painting of the background is finished off with blue and gray. Start to blend the strokes with the fingertips. The shading of the flowers in the upper parts is continued with orange, leaving areas in which the paper color can be glimpsed through. Start to work on the texture of the small flowers by making direct strokes in yellow pastel. Two different yellows are used. Black is used on the stems of the flowers, and on top of this color, different green tone marks are made.*

5. *Complete the blending of the gray background tones. All this area is unified by the fingertips, but without touching the flowers. Color touches are added to the yellows that were previously blended into the background. Yellow is now the base for further applications. The white flowers are also softly blended, but do not completely remove the glimpses of the colored paper.*

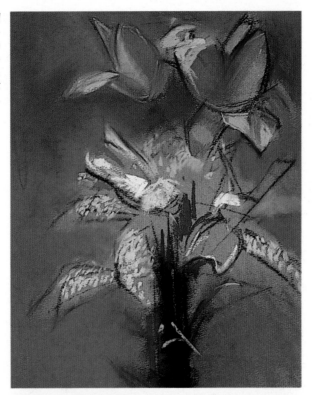

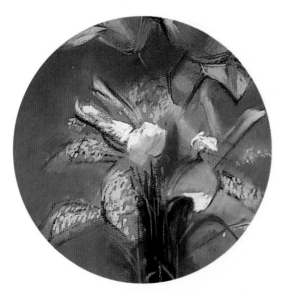

6. *The first applications of color have now been completed. All new additions are going to define and describe details of the forms in some areas, like, for example, the flower stems. As can be seen, the opaqueness of the pastel allows luminous blue strokes to be painted over the black background.*

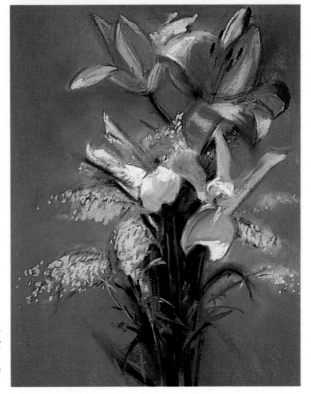

7. *On top of the tones of the upper flowers, do new strokes combining different colors, but without doing any blending. The highlights are applied directly: you do not have to use your fingers.*

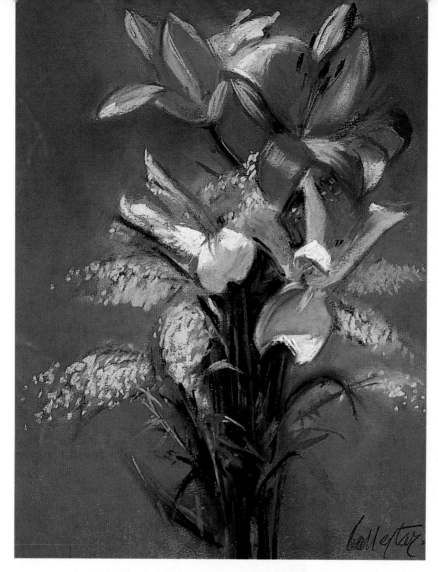

8. *The painting of the flower stems is finished off in a great variety of green tones and colors. The dark parts in this area are a perfect base to represent the depth of the shadows. Complete the outline of the white flowers with the dark tones and colors around them. Finally, numerous direct yellow strokes are added, which end up mixing with the earlier ones and the tones blend into the background.*

SUMMARY

The initial layout is completely geometric. In this way you can set out the whole composition without entering the details.

The shading of the upper flowers is very manneristic. Start with just two colors.

The white flowers are outlined by the tones that surround them.

On top of the initial black color of the stems, paint in luminous green.

SEPARATING THE COLORS

Tricks do not really exist in painting; they are just correctly used effects. In this chapter we are going to do various examples that show the advantages of pastel: how and when to use them. Some areas are to contain blended tones. Other areas are to be linear, formed by unblended strokes and stains. In the following example both methods can be studied.

One of the most widey used effects in the pastel technique is blending tones by rubbing the fingertips across the surface of the paper. This topic presents a series of important issues that must be kept in mind when developing a picture. A beginner must learn how to use each effect to the right degree in each area. Due to a lack of experience, some artists construct the whole picture only blending, which means that the stroke marks and the freshness disappear completely. Others prefer to use strokes but go too far and convert the piece into a pastiche of marks.

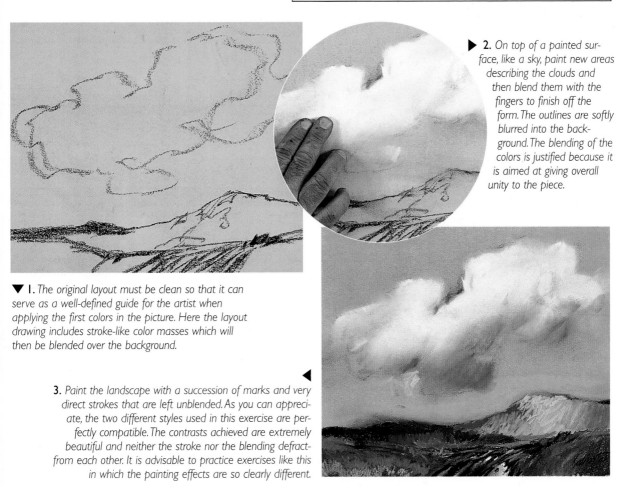

▶ **2.** *On top of a painted surface, like a sky, paint new areas describing the clouds and then blend them with the fingers to finish off the form. The outlines are softly blurred into the background. The blending of the colors is justified because it is aimed at giving overall unity to the piece.*

▼ **1.** *The original layout must be clean so that it can serve as a well-defined guide for the artist when applying the first colors in the picture. Here the layout drawing includes stroke-like color masses which will then be blended over the background.*

3. *Paint the landscape with a succession of marks and very direct strokes that are left unblended. As you can appreciate, the two different styles used in this exercise are perfectly compatible. The contrasts achieved are extremely beautiful and neither the stroke nor the blending defract-from each other. It is advisable to practice exercises like this in which the painting effects are so clearly different.*

Topic 6: Blurred edges and outlines

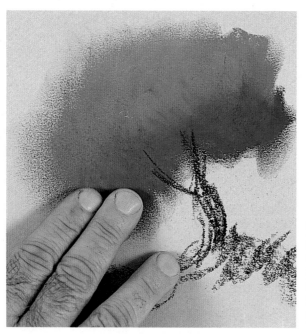

PROFILE OF THE AREAS

In the previous section we studied an exercise in which we practiced blurring and using different strokes in different areas of the picture. However, both work styles can be combined to bring out the best of the pastel properties. On this page we are going to show an example of how one style of painting can be combined with another.

▶ **I.** *When you paint with pastel you can choose to leave the stroke on the paper as it comes off the stick, or you can spread it with the aid of the fingers. Spreading a mark with the fingers helps to model forms like the base of the tree top. Firstly, make a pastel mark, and then spread the color out with your fingers until it blends with the background. The blending is slightly blurred at the edges.*

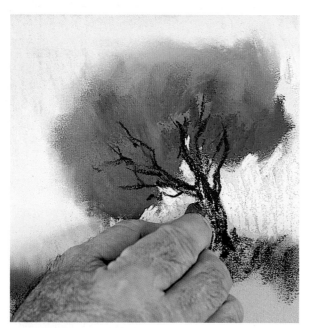

▼ **2.** *On top of the smudged color, apply direct strokes. The background color on which they are laid enables the definitive forms of the trees to be outlined. The colors painted earlier provide a perfect base as they show through the peeks left between the color masses. One of the interesting effects in pastel painting are firm strokes which leave a mark and a mass of color on the paper.*

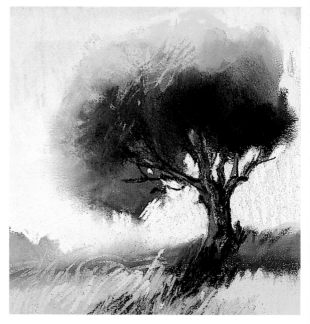

▼ **3.** *After outlining the branches, do the same with the rest of the picture areas. Superimposing layers of color will be one of the most widely used effects from now on, as well as painting with softened edges and building up layers that are left much fresher and spontaneous.*

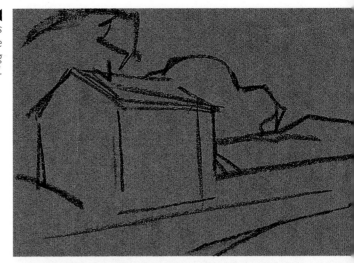

1. Before starting the landscape contrasts, it is important that each of the areas is specified in the drawing, otherwise the colors will end up getting mixed, which must never happen with pastel.

SIMULTANEOUS CONTRASTS

Behind this complicated title there is a technique that is common to all drawing and painting methods. It refers to the optical effect created between tones and colors in the picture. In reality, it refers to the laws of optics and the way the human eye functions. When a luminous tone is painted between dark tones or colors the former will be seen much more clearly because of the contrast effect with the darker tones. This also happens when a dark tone is placed between light tones. The dark part will appear much denser. In this exercise we are going to practice this interesting visual effect.

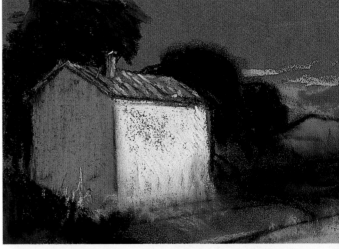

2. When the initial sketch has been set out, the marks must be added according to the way you intend to use the contrasts. In this example the highlight is going to be on the small house in the center left. Do the rest in darker and more contrasted tones and colors to increase the luminous tone of the building.

In the pastel technique, the tone of the paper is important when the other colors come into play. Dark tones painted over dark paper will seem darker than they actually are.

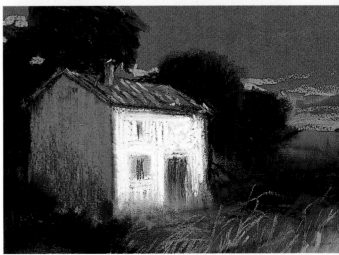

3. As can be seen, although the white of the house is the most luminous tone, it does not have to be painted completely pure. Other clear tones like Naples yellow can play a role. The contrast provoked by the darker tones that surround this tone allow it to be appreciated as a highlight.

Topic 6: Blurred edges and outlines

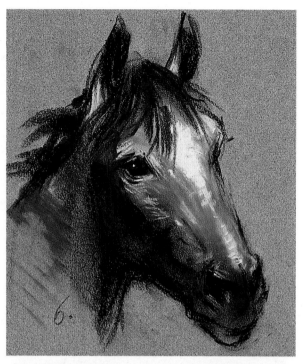

The two methods that are being explored in this exercise will be tried out with a common subject but on different colored papers. The pastels used to do these horses' heads are the same. The aim is to show the extent to which the paper color can influence the result. In this exercise it is important to bear in mind the value of the tones since color values change with their background. Each of the paper colors responds in a different way to the stumping, although the same color pastels are used.

▶ *Draw this first head on gray colored paper. On this paper the colors stand out with great luminosity as gray is considered a neutral tone: it only influences the other tones through the simultaneous contrasts created by the lighter tones. The background color comes perfectly through the initial stumping. On top of this blurred color, draw with direct, strong strokes which will integrate well on this tone.*

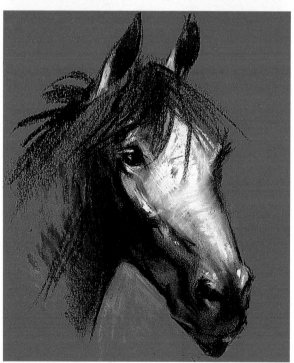

▼ *The exercise here is the same as the last one, although in this example the paper used is red. As you can appreciate, the contrasts between the dark parts and the clear areas show through with great naturalness.*

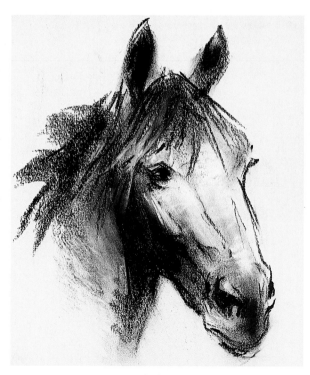

▼ *It is cream colored paper that allows the greatest naturalism in the tones and colors used, as it is not at all compromised by the contrasts created by the paper background tone.*

Step by step
A loaf of bread

As you will come to realize in this exercise, an ordinary loaf of bread can be a good model to practice several painting techniques presented in this topic. The model choice is always important, although it should not be a question that determines whether you start painting or not. This would be a great error because the most ordinary object can be represented in such a way that it takes on a new dimension and is worthy of being considered.

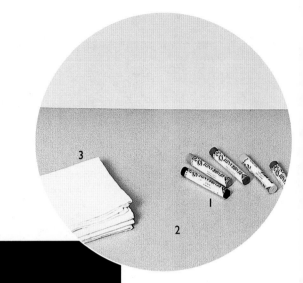

MATERIALS
Pastels (1), gray colored paper (2), and a rag (3).

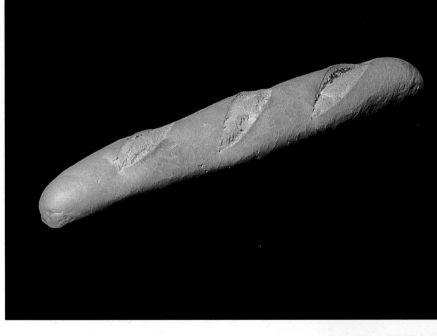

1. *The layout is started with a luminous color that stands out markedly on the paper. Once the corrections to the drawing have been made, the first contrasts with black pastel are started. The stroke has a very noticeable drawing style. It goes along the lower line marking out the definitive form of the bread.*

STEP BY STEP: A loaf of bread

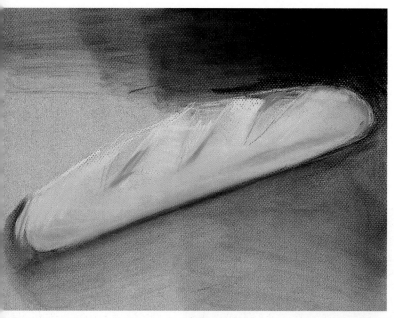

2. *Use the black pastel stick to strongly darken the background and to mark out completely the form of the bread. Use your fingertips to smudge the entire background. Inside the bread stick, paint golden yellow strokes and observe their characteristics. Each group of lines follows the form of the plane. On top of these recently drawn lines, the first contrasts are painted in red. They are softly blended with the fingers, but do not go all the way.*

4. *In this close up you can see how important it is that some painted areas remain fresh and intact. The contrast between completely blended strokes and others which remain untouched during the painting process is the key to painting in pastel.*

3. *Darken the upper part of the background totally, without shading the inside of the bread. This makes the contrast absolute. In the lower part, blend the dark color, and on top of it paint in blue. The shadow of the bread is painted in an umber color, but without totally filling the area. The finger work helps the distribution of the shadows over the tones in the lower part.*

5. *Contrast the entire background by completely blending the tones used. However, to get some luminous nuances, especially in the foreground, add some blue strokes. On top of the blended surface of the bread stick, you can start new strokes that allow glimpses of the color underneath to come through. This time the color employed is a very clear ochre orange which stands out against the hazy shadow tones because of its purity.*

When you are doing the main contrasts, do not use extreme colors like black or white, at least not during the first stages. This will enable you to improve the color composition as you work with gradations of the same color.

6. *As has been discussed already, colors that blend with each other produce dirty tones due to the mixing. To solve the lack of luminosity, paint the blue in the midground once again. This time the area takes on a multitude of nuances. Then, apply direct yellow dashes onto the bread stick to restore the luminosity to these areas. Also, paint some emerald green touches to enrich the texture of the bread.*

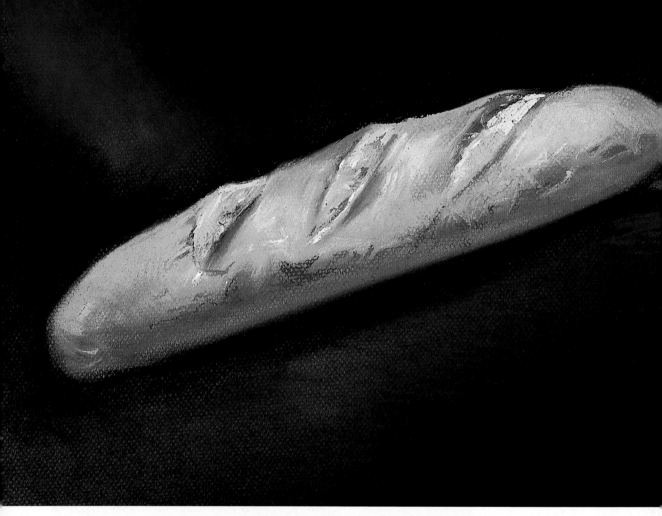

7. *Paint the table with cobalt blue in direct strokes that saturate the most luminous shadow area and increase the contrasts of the dark parts. The upper background, which was painted in violet carmine, will stand out much* *more because of the effect of the contrasts between the tones. To finish off, some luminous dashes are made on the hardest part of the crust. This will give the bread the floury look of having just been taken out of the oven.*

SUMMARY

While some strokes are almost completely blended others remain intact during the painting process.

In the lower area, blend the dark color. On top of it, paint in blue.

Paint the most luminous impacts at the end and leave them unblended.

The colors that blend together produce dirty tones due to the mix. This effect enhances some areas.

Background and motif

A SIMPLE EXERCISE

The principal motif of a picture is not always surrounded by other forms. Often it is in front of a completely plain or gradated background. However, the background is considered to be incomplete when the principal elements are badly placed in the picture. The problem can be solved by a simple correction, which can be rapidly done with pastel.

In all painting techniques beginners come up against an important problem when they have to decide on a crucial part of the picture: the difference between background and motif. It is not the same to represent an object directly on clean paper as it is to do it on a background, regardless of whether it is plain, has patterns or colors. Although a background may not have been painted, the color of the paper itself will take up this role, decisively influencing the principal elements of the picture. In this exercise we are going to try out different ways of resolving this interesting problem.

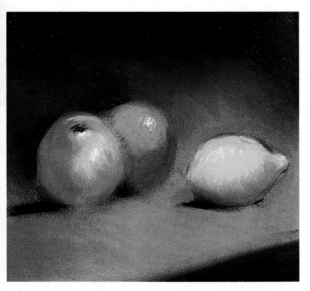

▼ I. *Observe how this still life has been resolved. The fruits that compose it have been laid out and developed against a neutral background. However, the relationship between these elements and the overall effect seems to have become lost in the disproportionate amount of space that surrounds the principal elements. It is not a poor application of pastel techniques that has ruined the picture, but the lack of harmony between the background and the motif.*

▼ 2. *It is not too difficult to correct the equilibrium between background and motif. A few additions, like the shadows and the diagonal in the foreground, give the picture dynamism and unity. It is these small issues that often go unnoticed by the beginner. However, if you practice exercises like this one, you will learn to see the equilibrium between background and motif very naturally. In the works of many great painters you can tell how they did correction exercises.*

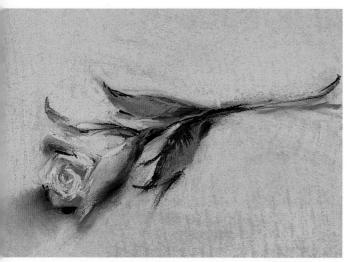

THE GREAT PASTEL PALETTE

There are many effects that allow the background and the figure to be compensated and in equilibrium. The immediacy and the vibrancy of fresh pastel color is one of them. Doing an immediate change to the background can rapidly give the whole picture a new atmosphere. The exercise on this page is an experiment to show the changes the form undergoes just by varying the color.

▶ 1. *The drawing of the flower is highly important because it does not depend on the color used to paint it. After having done a correct drawing of the flower, it is then painted in yellow tones. All the additions made to the background are going to exercise an influence on the contrasts in the picture. To start off, once the flower has been painted, the background is painted in yellow hues. The contrast between the background and the motif is minimal, although the color is in perfect harmony with the light.*

▶ 2. *On top of this example, add in ochre color tones so that the background makes the principal motif stand out more. As you can appreciate, it is important that the paper color, or in this case the background painted behind, shows through the new strokes. This will allow the whole picture to gain in unity and atmosphere.*

> When we refer to the background and the motif, do not interpret this strictly. It means the relationship between the principal elements of the picture and the elements around it.

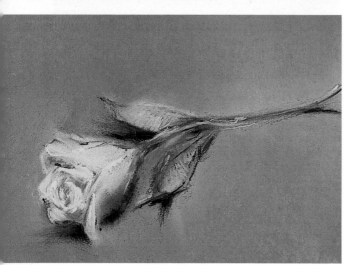

▶ 3. *Paint the entire background in dark sienna to create an intense contrast with the principal figure. Do not cover the paper completely. This will give the picture greater depth and make the flower more prominent against the two surfaces. If you go back over this exercise you will be able to appreciate how each of the additions made on the background have influenced the shadow tones of the flower.*

CREATING FOCAL POINTS AND BLENDING

In addition to the simple effects for working on the background and motif in pastel, there are a great many other techniques that give spectacular results, starting with creating focal points and tone blending. In this way it is possible to separate the background and motif by creating different visual focal points, leading the eye towards specific areas. This exercise will help you to understand how to master pastel techniques related to issue like the center of interest of the picture.

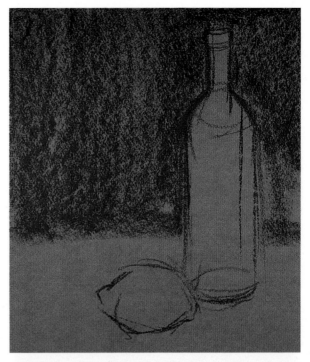

1. This is a simple composition with two principal elements against a background with highlights that outline the principal elements. The stroke is quite evident and has been done in a uniform way.

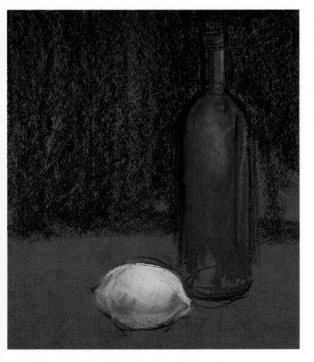

▼ *2. One way of increasing the focus of the principal elements relative to the background is by blending the background strokes. You must be especially wary not to smudge the form of the principal elements with your hand or fingers.*

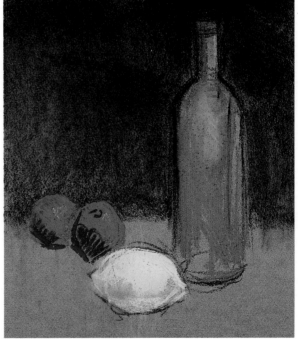

▼ *3. Once the background has been blended, the composition can be enriched with new elements drawn and painted in luminous tones. When these fruits are painted, the background color becomes their base color. Later on the color values of the fruit will be effected by these tones.*

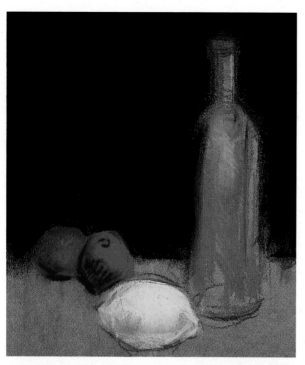

MAKING THE FORMS MORE DEFINED

In this exercise we can see how new, perfectly integrated additions can be made to the colors on top of a painted background. The focus of the new forms can be increased if the background behind them is altered. Observe how the background plays a key role in defining the different elements, depending on the plane that they occupy in the picture.

▶ **4.** *The elements which have just been painted in the background play an important role but they are not sufficiently contrasted against the background. This contrast can be achieved simply by darkening the background. The strokes are done in the same way as the first application, but with the difference that now the background serves as a tone which shows through the new contrasts. As all the background is darkened, the picture becomes more luminous, even the elements painted last of all.*

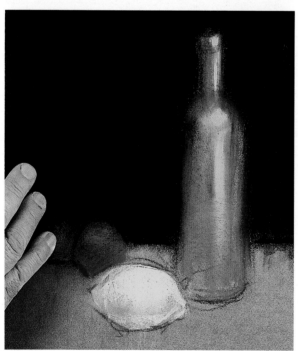

▼ **5.** *To separate the different planes in the still life all the elements in the deepest part of the background are integrated into the darkness by delicately blending the outlines of the new elements to tone down their forms. Remember that it is not a question of mixing the colors but rather of blending the edges of the fruit.*

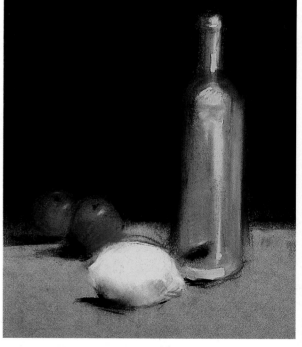

▼ **6.** *The highlights give the necessary luminosity to the picture. In the foreground the highlights can be achieved in a much more direct way, and in the midground they are far less defined.*

Step by step
Landscape planes

The subject that we will paint here is a mountain landscape with trees and different types of vegetation. Besides the subject itself, special emphasis will be placed on one of the most interesting points in painting: the relationship between the background and the motif. In this exercise it is essential to give the right value to each area, something which many beginners omit. The relationship between the motif, or principal element, and the background is manifested in an interplay of colors, tones and contrasts between the different areas. This is easy to create in pastel.

MATERIALS
Pastels (1), dark green colored paper (2), and a rag (3).

1. The principal elements in the landscape are sketched and a layout is made in black pastel to establish a good contrast, whatever the base color may be. Even at this stage, with the painting in this undeveloped state, the priorities between the background and the motif should be established. Observe how the contrast on the main tree separates it perfectly from the other elements in the composition.

STEP BY STEP: Landscape planes

2. *The principal planes have to be separated so that the situation of the each is clear. To do this you must first paint the most distant plane which includes the sky. Even this zone is related to the background: do not shade with just one plain color, instead paint tone variations to bring out the relationship and the contrasts between the elements in the foreground and the background of the sky.*

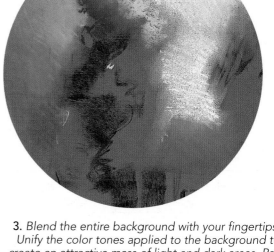

3. *Blend the entire background with your fingertips. Unify the color tones applied to the background to create an attractive mass of light and dark areas. Pay attention to how the plain color of the paper varies according to the tone around it. In the white sky areas, the green of the paper becomes dark due to the effect of the simultaneous contrasts. However, where the sky is blue, the contrast with respect to the green appears much more balanced.*

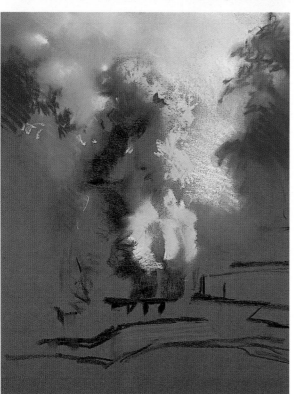

4. *In the first step we put highlights in the foreground with the aim of compensating the background tones, in this case the sky plane. Continue to paint the light area of the trees with sufficient pressure so that the tones are compact and completely cover the background color. It is noticeable that in this area the color of the paper plays a role as if it were just another tone in the range.*

5. *Continue painting the main light areas in the land-scape. This means that the color of the paper can be included as a perfectly defined dark tone. To represent the medium tones in the landscape look for tone variations which can be blended in, and which can establish a new relationship between the background and the motif as they create a new plane which defines the foreground.*

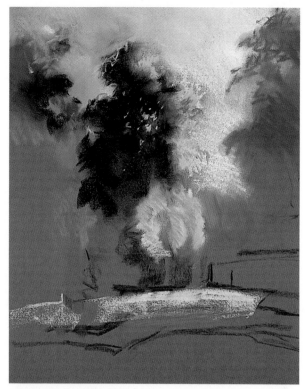

The relationship between the motif, or principal element, and the background is transformed by playing off the colors, tones, and contrasts of one area with those of another.

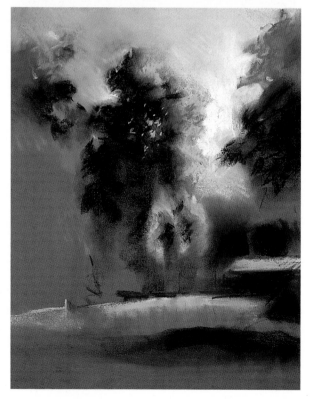

6. *When the darkest contrasts are applied, a considerable change is produced with respect to the previous steps. Putting black pastel down on the right allows the background color of the paper to be seen perfectly in some areas. Moreover, blending dark areas elsewhere aids the integration of the paper color with the pastels. In the foreground, mark the shadow area with a grayish blue. This tone will be the definitive base for the final step.*

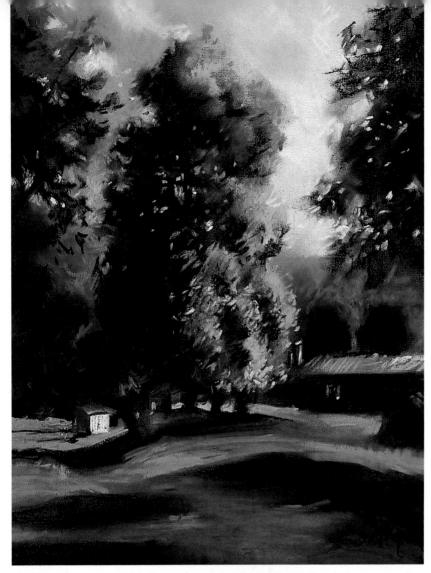

7. *Remember that in pastel technique mixes do not exist. All the colors applied come directly from pastel box. However, it is likely that some beginners do not have all the colors detailed in this exercise. Do not worry, it is always possible to use a similar color. Green is used to paint the luminous parts of the grass. Paint the shadows of the foreground in dark blues and grays. Finally, the bright touches in the main tree are applied with direct pastel dabs to make the trees and foilage blend into the sky background.*

SUMMARY

Painting the sky sets the landscape planes. The blue tones will have to be compensated with the tones that are applied in the rest of the picture.

Blend impacting light blue in with the background and the motif.

Balance the highlights in the trees with different bright spots in the sky.

The paper color shows through the marks and the strokes, blending in like the other colors from the palette.

8

Contrasts and colors

GRADATIONS

The possibility of doing gradations, the way one tone gradually turns into another, is one of the principal strong aspects of pastel. We have practiced various types of gradations. Here we are going to work on gradations and contrasts with colors. Gradations are useful because they offer a succession of tones, or of different colors blended together, to form a harmonious color composition.

> Nothing works better than pastel in creating color blending effects. However, blending must not be confused with mixing, which must never be done. Blending, which forms part of the pastel technique, allows us to do more precise shapes. However, if we do not blend we can juxtapose colors that act as contrasting planes.

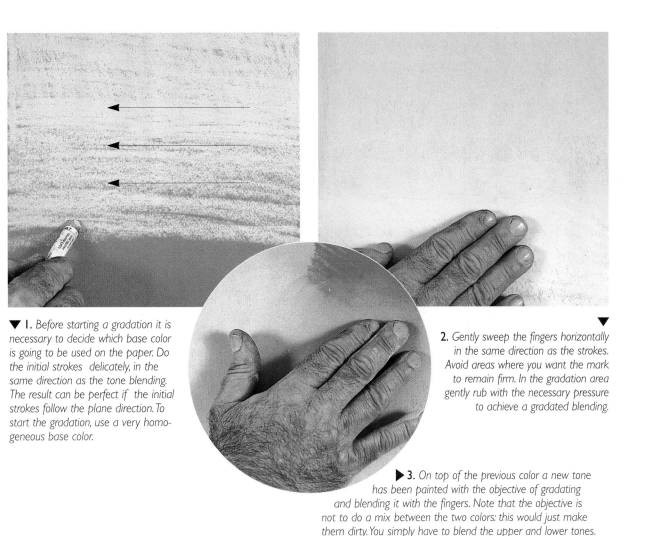

▼ 1. *Before starting a gradation it is necessary to decide which base color is going to be used on the paper. Do the initial strokes delicately, in the same direction as the tone blending. The result can be perfect if the initial strokes follow the plane direction. To start the gradation, use a very homogeneous base color.*

2. *Gently sweep the fingers horizontally in the same direction as the strokes. Avoid areas where you want the mark to remain firm. In the gradation area gently rub with the necessary pressure to achieve a gradated blending.* ▼

▶ 3. *On top of the previous color a new tone has been painted with the objective of gradating and blending it with the fingers. Note that the objective is not to do a mix between the two colors: this would just make them dirty. You simply have to blend the upper and lower tones.*

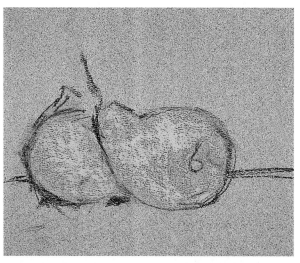

TONES

Tones are the reflection of the fact that a color or a family of colors can gradate. With pastel, as with other drawing media, different tones can be achieved by studying value and the blending of one tone on top of another. However, pastel is different in one way from the other drawing media in that it can be completely pictorical: by combining tones and playing them off against each other it can produce mixing effects normally associated with strokes or shadings. In this exercise we are going to be working with tones, blending dark over light.

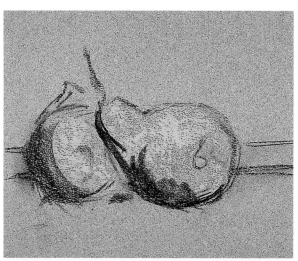

▶ **1.** *Doing this tone exercise with fruit as the subject ties in well with many different drawing concepts. However, as soon as the paper color background forms part of the chromatics of the picture, the initial concept of the drawing varies as the guidelines of painting take over. Once the first shading is made, the parts of the background that show through, blend in with this luminous color.*

▶ **2.** *On top of the first yellow tone, add in a dark color. Later this tone will be blended with the first color but this does not mean that the whole range of pastel colors will vary because you are not going to mix any colors; you are only going to blend warm tones together.*

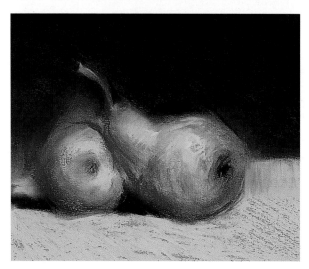

▶ **3.** *Paint the entire background in such a way that a strong contrast is created between the foreground colors and those behind them. Paint the foreground of the table in an orange tone to finish off the color composition. Do the color blending with your fingers, rubbing one tone over another. To gradate the tones it is advisable to use a palette of colors of the same range.*

TONE AND COLOR CONTRASTS

Colors can be approached in two very different ways. As we have seen, blending two colors as if they were tones can easily become a modeling exercise. Nonetheless, you can also opt for a different work style: the contrasts do not have to be produced by directly blending the tones; you can produce them by directly contrasting colors. Working like this gives eye-catching results which are enhanced by the pastel technique. In this exercise the work will be twofold. The first stage is blending the tones, and the second phase is the direct color contrast.

> To check on the optical effect of some contrasts it is wise to do a test beforehand on paper prepared for this type of work. When white paper is being worked on, the tests can be carried out on everyday paper.

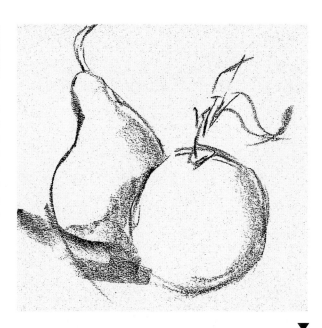

1. *Whatever the pastel piece may be, the preliminary sketch is of vital importance to the construction of the composition. This layout style can be used in the following two exercises. Just a few lines are required to suggest the forms of the two pieces of fruit. At this stage all painting methods are the same.*

▼ 2. *In this amplified close up of the painting you can appreciate the blending of the tones and the way the darks gradate over the light areas until they are perfectly merged. Both the deeper shadows and the light half tones blend softly with the lower layers to give tonal contrasts.*

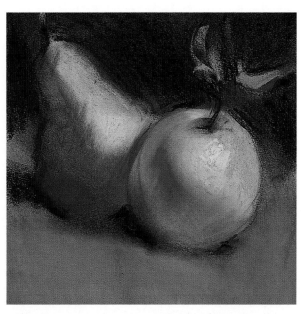

▼ 3. *When the piece is finished, you can observe how the shadows blend with the most luminous tones. The light tones do not make a striking color contrast, rather they are differentiated by the complemetary contrasts. Summing up: the light areas and the dark areas mutually strengthen each other.*

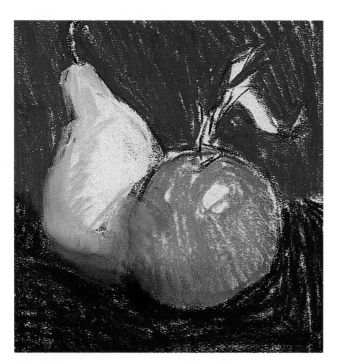

CHROMATIC CONTRASTS

In the first part of this exercise we studied how light areas and dark areas can be blended together following the same tone scale. This second exercise aims at working on the same topic as before, but with a completely different understanding of color. This time the contrast created is not tonal but chromatic. Pay special attention to the different planes and how the colors react to each other.

▼ 1. *This exercise starts with an identical layout as before. The opening lines allow you to start conceiving the work, regardless of how it will be continued later. Start the exercise by applying very defined colors that contrast strongly with each other. The first strokes are direct and spontaneous.*

▼

2. In this close up you can observe that although some areas blend together, others have a fresh and direct finish. The areas that merge are next to others which still have the original stroke pattern, through which the paper grain and color can be seen.

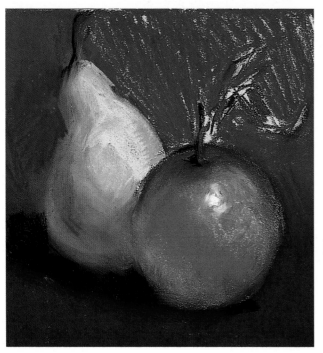

▶ *3. Although it is important that the colors contrast strongly with each other, the tone mixes also play a role. For example, in the background the brightest blue is mixed with a less intense and much darker blue area. It is crucial that the different colors do not interfere with each other, or if they do, that it is as discrete as possible to avoid the danger of the different colors becoming mixed up. A blue can mix and blend with another blue, but it must never do so over an orange.*

Step by step
Seascape

The blending and contrast of tones is a constant aspect of all pastel techniques. Sometimes the color can be treated as if it were cloud-like and expanded over the paper without fixed limits. At other times the color will have perfectly marked forms and the stroke mark will be visible. To put the blending and stroke contrasting techniques into practice we are going to do a seascape. This is a straightforward exercise despite the intimidatingly magnificent result below.

MATERIALS
Pastels (1), blue colored paper (2), and a rag (3).

1. *Painting in pastel can often seem like drawing. However, at this stage, since the painting develops in opaque color layers, this first layout does not have to be an accurate drawing. To start this exercise, put in a high horizontal line, leaving a vast expanse of sea which is more than sufficient to practice all types of blending and tone superposition exercises.*

77

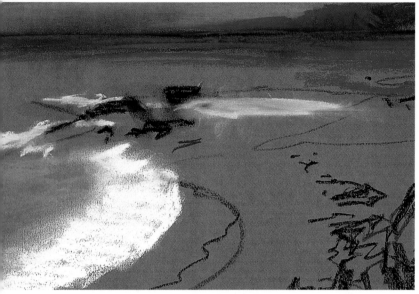

2. *The color range that is going to be used to elaborate this seascape belongs to the harmonious cool range, which consists of greens and blues. Using this restricted scale, and taking advantage of the color of the paper, the contrasts that are applied will not be chromatic but tonal. Firstly, paint in the narrow strip that corresponds to the sky. Work on the sea with a strong luminous blue that contrasts with the paper. Paint the foam where the waves break directly in white. Then immediately tone down the stroke with your fingers.*

3. *On top of the white foam of the sea put in some blue marks. These are perfect for blending with the fingers. Outline the frothy edge of the sea in a greenish tone, and next to this color paint in blue before finishing off the blending. On the right you can start the waves splashing against the cliffs in jabbing little white strokes.*

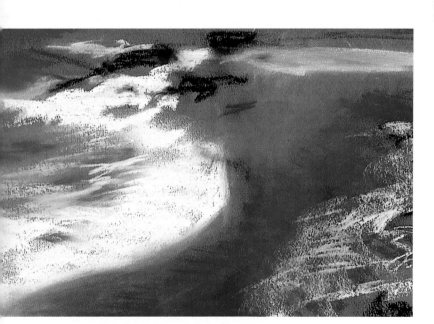

4. *A progressive blending of blue tones starts out from the horizon using ultramarine blue. However, do not let it cover the paper completely, allow its color to show through in some places. You can see that there is a clear difference between planes: they are separated by a horizontal whitish line and the rocks on the left. All the frothy parts are painted with direct white strokes and little dashes.*

Remember to reserve the brightest areas, where the highlights will go, because, together with the maximum contrasts, they will be painted last.

5. In the lower area where the waves break against the reef do a color blending of the white against the background. Then immediately draw with the white pastel stick. This time the stroke is direct. On top of the rocks in the foreground, which were stumped in black, lay down blue strokes and then softly blend them with the darkness already on the paper. This will give shape to every rock. In the background, above the line of the horizon, the form outlines can be finished off. As you want to avoid the stroke marks being too direct, gently blend them with the fingers.

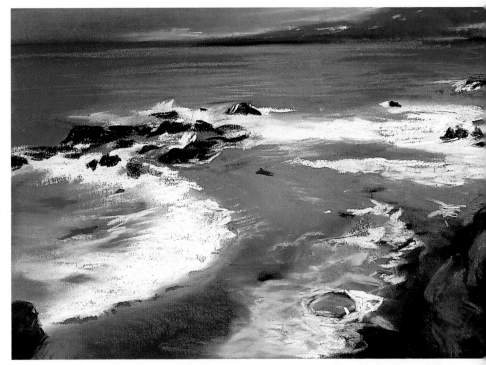

Blend the base color in the background to create an initial layer of colors without a definitive outline.

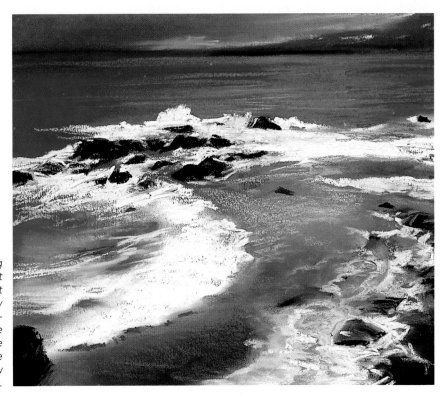

6. Direct strokes and blending are very important to represent the sea foam. This step is not difficult, although it is necessary that the base white color is gently integrated over the blue background tones. Once the different tone blendings have been done you can add new white jabbing strokes.

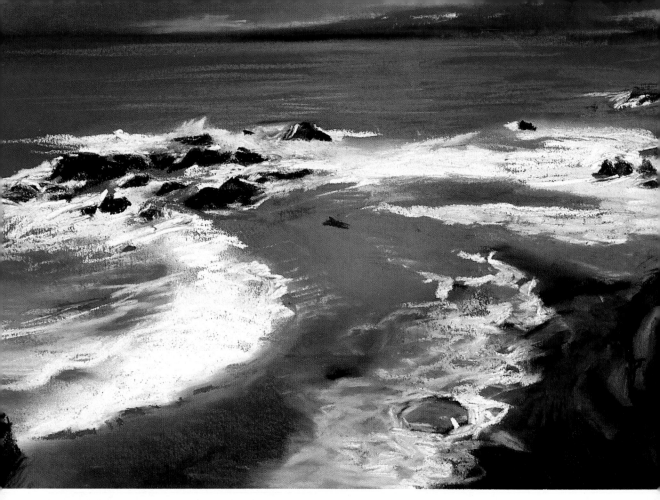

7. *In the intermediate area between the foam do some new color blendings. However, make these more subtle. In the upper part of this area, the pastel stick is used flat and lightly, thereby enhancing the* effect of the texture. *Outline the dark parts of the rocks with the pastel point. All that remains to be done are some direct white touches above the horizontal sea spray line to create the impression of splashing.*

SUMMARY

The middle distance marks the difference between the two planes in the picture. Below this line the work will be much more meticulous.

Once the wave tones have been blended you can do new direct additions that bring out the texture and contrasts.

Blend the first white color addition into the blue tone background.

Over the black rocks paint in blue.

Fixing pastel

FIXING THE FIRST LAYER

The first layer can be fixed provided that it will not have to be corrected later, or if the picture is going to be covered completely with color. Spray fixative is a good tool if it is used in moderation and at the right moment. In this first exercise we will show some of the effects that can be used before and after the first layer, which may only be the design drawing before the color is fixed.

On numerous occasions in this book we have mentioned that pastel is a fresh and spontaneous medium, however this characteristic could be lost if it is fixed. Using fixative can be very helpful when you are doing the first layers. It is worth pointing out that the finished painting should never be fixed. The methods explained in this chapter will help you to get the most out of pastel and the effects you can use.

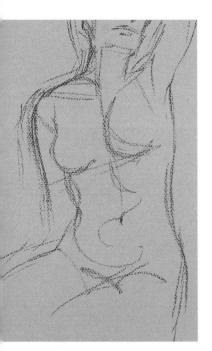

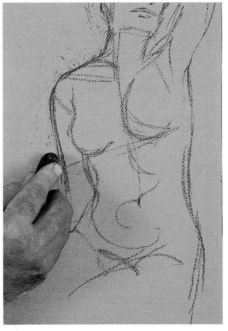

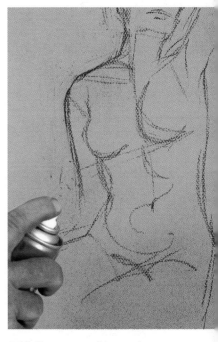

▼ 1. The sketch can be done in line or side strokes. It can easily be corrected by rubbing out or by drawing over the lines. Do not press too hard with the pastel stick so that corrections can be made later without leaving the stroke too marked on the paper.

▼ 2. The eraser can restore the definitive lines. Thus the sketch will become much more defined and can serve as a firm base on which to paint. The fundamental lines have to be kept clean of all extra strokes.

▼ 3. Once you consider your layout drawing to be complete, you can fix it. The fixative must be sufficiently far from the paper so that the spray forms an even film, without leaving drops. Once the drawing has been fixed you can only correct it by painting on top of the varnished drawing.

Topic 9: Fixing pastel

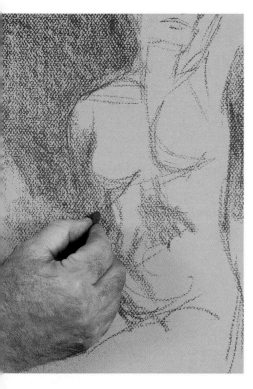

▶ **1.** *Fixative dries very quickly and allows you to continue using pastel almost immediately. If any area is damp, it is wise to wait for a few moments until it is completely dry. The wet areas shine a little until the moistness completely dries them up.*

SECOND LAYERS ON TOP OF A FIXED BACKGROUND

The fixing process guarantees that the initial strokes are preserved. However, it also allows you to establish certain shading and color effects as a base for the final finish. The new compositions that you make will not effect the lines fixed beforehand.

You can make new pastel strokes on top of the perfectly fixed drawing. The effects for this exercise have been chosen to demonstrate different composition and fixing techniques.

3. *Fixing the first layer means that it is possible to redo the painting as many times as you need to, adding either contrasts that outline the principal motif against the background or highlights that give volume to the forms. Use direct stains or strokes, letting the underlying color show through. Applying another layer of fixative would just clog up the stroke.*

▲

▶ **2.** *As can be seen, when the color just put down is spread with the fingers, the drawing that was fixed in the first part of the exercise remains stable and visible. Regardless of how much you rub it, neither the background nor the new colors will disturb it.*

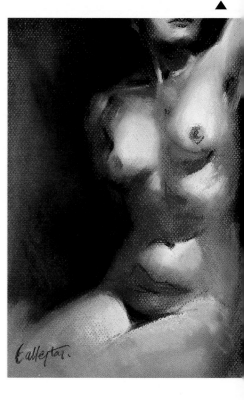

COMPOSITION AND CONSTRUCTING THE PAINTING

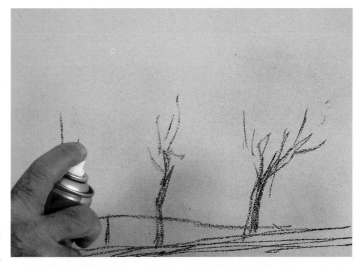

The unique properties of pastel open up a wide range of possibilities and effects. Bright, vibrant colors can be placed next to each other. You can then overlay them, correcting as you go along. Pastel fixing enables you to secure entire layers that will be the color base for later layers, no matter how many you may lay down.

1. *As you could appreciate from the last exercise, the layout, can be fixed once it is totally finished. Fixing can be very useful for even a simple landscape sketch. As you will now see, the color effects created on this perfectly-defined linear drawing do not alter the original forms. It is not important if a few preliminary sketch lines remain, as is the case here, because later the colors applied will cover them up.*

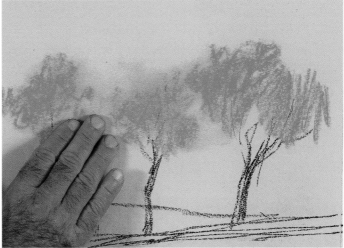

2. *Once the support sketch has been fixed the first color applications can be made. These strokes are then blurred with the hand but the layout beneath remains uneffected. The preliminary sketch references enable us to rectify and retouch the landscape forms. If you have to flick off some pastel, the lower levels will remain stable.*

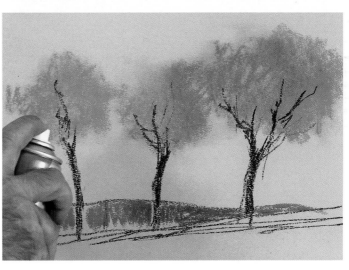

3. *As we are going to continue working on the picture, putting in more interesting color layers, spray on another very faint layer of fixative to ensure that you have a solid base on which to work a whole range of effects without altering lower layers. Above all, bear in mind that you must never fix pastel when the piece is finished, and that when it is used, fixative must be applied in very fine layers.*

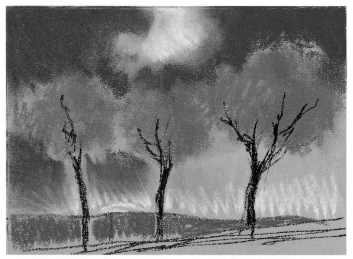

EFFECTS OVER A FIXED BACKGROUND

A color base is the best support that can be used with pastel: the new colors will be enhanced if the chromatic base increases the contrasts and the effectiveness of the blendings. In any case, as we have said before, fixative can only be used during the first additions because we want to preserve the freshness and spontaneity of the final strokes.

▶ **1.** *The previous color base is perfect to continue the picture by adding new color or tones. Here, you can observe how the clouds are painted and blended on the background without the color mixing. From now onwards, any correction will have to be resolved by adding a new color layer above it. Just as the clouds were painted without altering the layer underneath, strokes and shading are added to the tree allowing the under layer to show through in some areas.*

▶ **2.** *For the ground, the details can be resolved with a direct style. The background color is a very apt base for new tones that are applied in pastel. In this area of the picture the different effects can be combined with direct strokes or color blending.*

> Painted layers of fixed colors make a good base for pastels to stick to, rather like a primed surface.

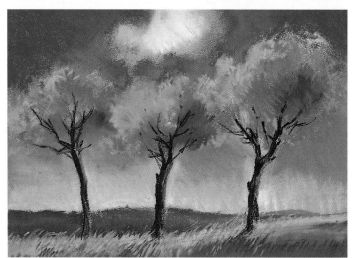

▶ **3.** *A direct or fresh finish can be the ideal solution when using the effect of fixative at different stages. As can be seen, the lower layers show through the perfectly marked off and consructed new areas. The new blendings do not mix with the background colors thus giving the pastel an incomparable freshness.*

Step by step
Flowers

The pastel technique is the freshest and most spontaneous pictorial method, provided that you use it correctly. If you do not master the technique, or if you go beyond your limits, a picture that began with color and style could be spoiled simply by spraying fixative at the end of the piece. Timing is very important: never apply it at the end of the process. In this exercise we are going to paint some delicate flowers, with an emphasis on expressing the delicacy of color.

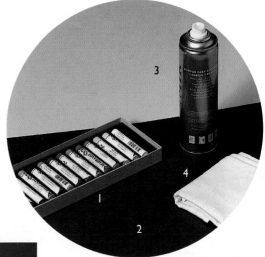

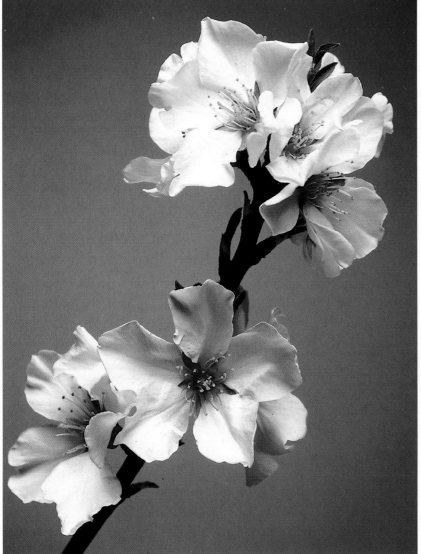

MATERIALS

Pastels (1), dark blue colored paper (2), spray fixative (3), and a rag (4).

1. *As we have chosen dark colored paper, the best way to sketch the drawing is starting with a very luminous color, like white pastel. Sketch the principal lines with rapid strokes, only working on the planes. You can leave out the details for the time being.*

2. *Start the painting of the upper flower in a gray tone, which will appear to be luminous, even on the dark background. This color is perfect for the areas of the flower which are in shadow, using hatching – a series of lines drawn closely together to give a shading effect. Use pure white for the brightest areas of the flowers: all the tones that are going to be developed are now in place. Outline the form of the flower by painting the background in marine blue, one of the most beautiful and luminous pastel colors. Use your fingers to blend the white over the blue background to give a much more whitish blue than before.*

3. *Continue painting the upper flower applying direct white color. Above this, paint gray to obtain the medium shadow tones. Without going so far as to completely block out the drawing form of the petals, blend the contrasts which appear overy brusque. This blending is extremely easy. The background paper color acts as a dark contrast between the petals.*

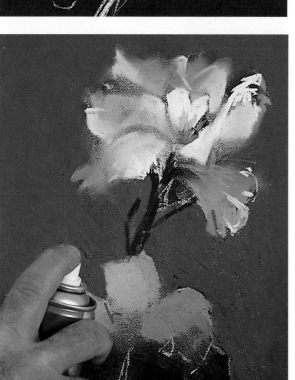

4. *On the upper flower, start to paint some very direct white strokes to position the highlights. Bright orange and yellow strokes depict the center of the flower. Paint the stem with rapid strokes in dark green: do not go into details. Apply a layer of fixative to the entire piece. Hold the spray can far enough away so that the fixative does not clog up the paper surface or make the pastel sticky or stodgy. A light spray will suffice to protect the work against dirt or friction.*

5. *The previous base has been fixed with the aim of protecting it as you continue working. For example, the new gray that has been painted on the petal of the upper left flower can be spread over the lower colors without dragging them in the process. Finish off the highlights of the petals that touch the background in this same way. The same approach is also valid for new orange touches that enrich the shadows.*

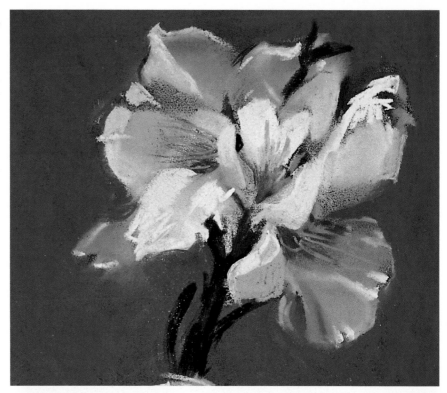

When you use a pastel fixative it is advisable to choose a well-known brand. Good quality manufacturers go to great lengths to ensure that their products do not interfere with the techniques or media used.

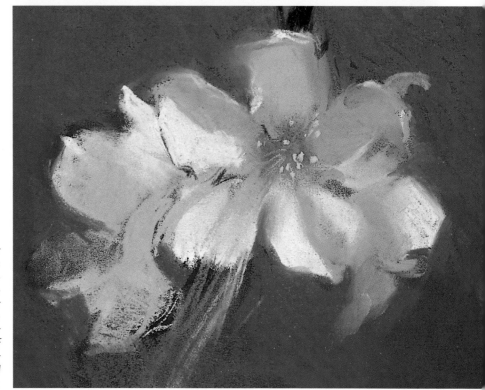

6. *While painting the upper area, you used the tones as the base for new color additions. You can do the same with the grays on the lower flower: when they have been fixed use them as a base for fresh tones. The blending of these colors will in no way effect the lower colors. Fixed colors do not mix.*

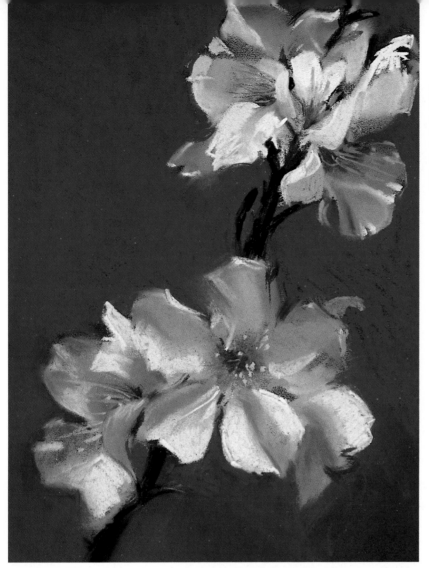

7. *Paint nuances of color that blend in with the edges of the colors underneath. This allows us to overlay new grays and very precise highlights. Lastly, all that remains to be done is paint direct red strokes and a few yellow dashes.*

SUMMARY

A dark paper color means that the composition layout will be luminous. Here it is done in white pastel.

A blue much brighter than the background allows us to outline the flower forms. Establish highlights by painting the lightest tones.

Very luminous white details emphasise the flower outlines as well as the highlights.

Paint the grays of the lower flower over the already fixed pastel layers.

Background effects

THE COLOR OF THE PAPER

When the color of the paper is going to create the base tone of the painting, it is important not to cover it completely with the strokes. The background has to be played off with the new colors applied, just like another color in the range. The result is an atmosphere in which the paper color determines the lighting of the model.

Pastel is a medium that allows the colors of the lower layers to be seen through the new superimposed colors, provided that the paper grain and pastel stroke are used properly. The background can have several different aspects: one unique painted or hatched color; a clean paper color; or several overlaid colors blended together.

▼ 1. We have chosen quite luminous red paper to do this exercise because we want the color to condition the atmosphere. Draw an oval shape to represent the plate, and on top of it, three spheres to outline the apples.

▼ 2. Paint around the apples so that their forms are perfectly outlined and the colors are defined. Paint the plate in very light tones and leave the reflection areas in reserve. When you work on colored paper both the light and the dark colors give value to this background. If you paint in a luminous color, the color of the paper will take on the value of a medium tone.

3. To finish off the fruit, paint in a very direct style with a few carefully placed highlights indicating the way the light falls. Soften them with the fingertips.

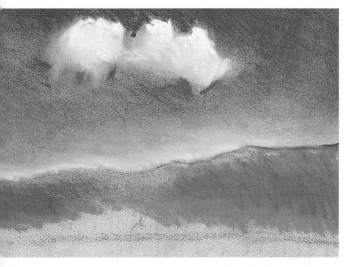

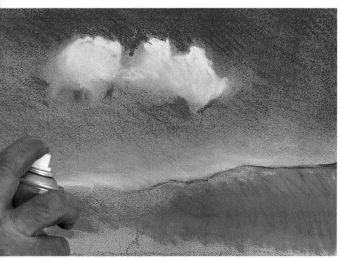

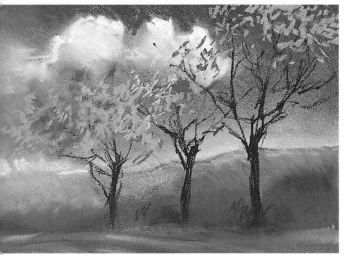

THE BACKGROUND

One option is to paint the background before working on the principal motif. Therefore, when you paint over it the base color will already be defined. This is a standard method in certain pastel paintings, especially when the background is complicated, such as a texture that could be altered by the main subject. Pay special attention to the steps in this exercise. Apply fixative to the background so that it is stable before you put on the different color layers.

▶ 1. *In the background part of the paper, paint all the areas that form the atmosphere, including the hidden parts of the picture. What really interests us is to have a perfectly defined base, on top of which we can paint the focal point elements. We could compare this first part of the exercise to preparing a theater stage set. If you temporarily forget about the principal elements, you can work on the sky, the mountains and the background with ease.*

▶ 2. *Once the first part of the exercise has been finished, you can fix all the work you have done so far. The fixative should be applied at a distance of about 20 cm., just a light layer that does not leave the paper sticky. Now the background is established and can be the base for the elements in the foreground.*

▶ 3. *The layer that has just been fixed must be allowed to dry before starting to work on the landscape foreground elements. Any alterations that you may wish to make will not effect the layers that have been fixed. Paint in the foreground, the trees and the fences. The background can be seen clearly through the tree branches. The picture must not be fixed again.*

COLOR HARMONY IN THE BACKGROUND

When the color of the paper in some way imposes itself as the base color it can be used to develop the color range of the picture. For example, in this exercise we will paint over a tobacco colored paper. All the colors used throughout its development belong to the same color range. Thus, it will be possible to establish beautiful color harmony.

◄ 1. *Tobacco colored paper is ideal for any theme. It is a great aid for obtaining a series of natural tones. Do the preliminary sketch in a very similar color to the paper so as not to provoke too strong a contrast. However, it must be sufficiently evident so that you can overlay the right colors.*

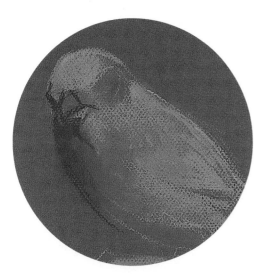

▼ 2. *Using tobacco colored paper does not mean that the tones have to be variations of that same color. All types of colors from the warm range can be used, preferably the earth tones.*

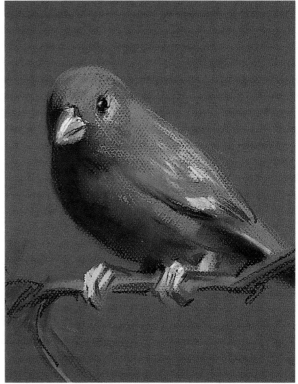

◄ 3. *The dark and light contrasts are added at the end. They mark out the forms and the dark areas outlining the bird against the background. As can be seen, the original paper tone shows through all the layers of color but there is no lack of harmony. The paper is the principal base of all the colors, uniting them together.*

SHADING AND STUMPING OVER THE BACKGROUND COLOR

In previous chapters the color of the paper has been considered as the chromatic base for the picture. This does not change throughout the pastel techniques: this medium is always much more luminous and effective when colored paper is used. The following exercise will not be difficult. It consists of combining marks, lines, stokes, and hatching with reserves of the color paper.

▶ **1.** *Draw the preliminary sketch in a very light blue pastel so that the flowers are left in negative (reserved). The paper color will be decisive in the first marks you do on top of it, and in the final tones of the picture.*

2. *Do the area around the flowers in very pale colors: press down hard enough to seal the paper grain in some areas. Add carmine and pink pastel to these flowers, but leave the blue ones untouched; they are going to use the paper color.*

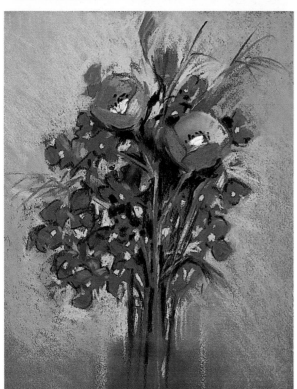

▶ **3.** *Do the highlights on the blue flowers with tiny dashes of a very light blue. In some areas this blue will blend perfectly into the background.*

Step by step
Landscape

When you take advantage of the background color, it becomes part of the range. This is what we are going to do now. Here we will do a landscape with a very limited range of colors. The final objective is to allow the base color to show through the pastels used and for it to work like the other tones. Paint on pastelcard so that the texture is very different to pastel.

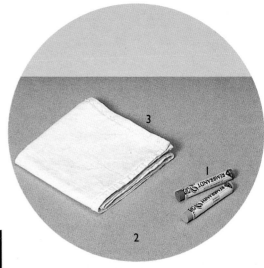

MATERIALS
Pastels (1), gray card (2), and a rag (3).

1. *Start with a layout of the landscape. These first lines must not be descriptive. They are only to position the masses. Draw with the different possibilities that pastel offers you: flat, crosswise and lengthwise. The tops of the trees have been outlined with soft strokes, made with the stick working crosswise. In the lower part, do very dense, lengthwise hatching.*

2. *Pastel is much more stable on card than on paper. The pores of this surface are quite closed, however, this first color layer could seal it completely. Use orange pastel to shade without covering the whole card surface: the stick is held flat between the fingers. The background color highlights the texture of the stroke.*

3. *When you paint the orange color over the blue it causes some dragging and a slightly green tone is created due to the mix. These are the only two pastels that are going to be used. Blue will create the contrasts that define the forms. The orange, apart from adding atmosphere, will compete with the blue and forge new tones due to the blending of the two colors.*

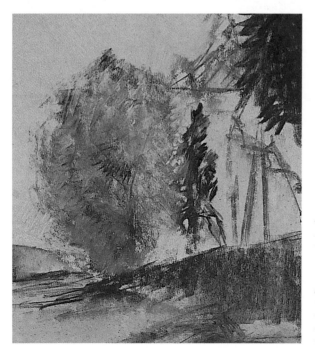

Doing the layout with the stick held flat allows you to use a uniform and very straightforward drawing style.

4. *It is important to maintain the presence of the support tone despite the different color applications. The strongest contrasts, realized in blue, make these small glimpses of the support stand out for their luminosity. On the right of the picture, paint with the necessary pressure so that the blue is dense and opaque. For the tree in the middle add alternatively, in a jabbing style. The two colors are then mixed gently with the fingertips. However, do not completely do away with the stroke.*

5. *Continue to progress with the small mixes and color blendings for the bushes in the background. To give the right volume to the texture, paint some very direct blue contrasts. The trunks are painted with back light, which gives greater presence to the orange color in the sky. Observe how the tones blend and how the overlays create mixes. In some areas the blue strokes are dense, while in others they hardly touch the card, thus allowing the orange and the background to show through.*

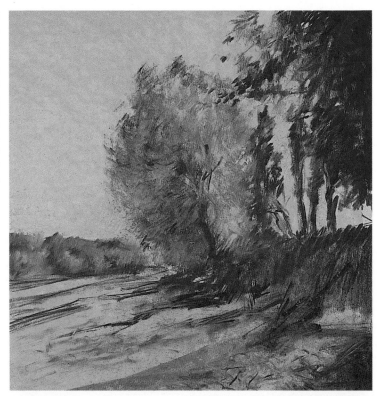

As the pores of the card support are very closed, the stroke tends to slip.

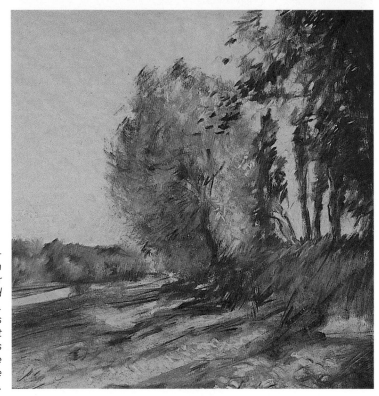

6. *In this step the emphasis is on the colors applied with a direct heavy stroke, in blue as much as orange. Center your work on the foreground where the land lies. Firstly put in the blue contrasts. Over this blue, and also over the areas which were blended before, make direct orange marks. On top of the dark parts on the right, mark directly with little orange touches. This will tone down the excessive contrast created by the blue.*

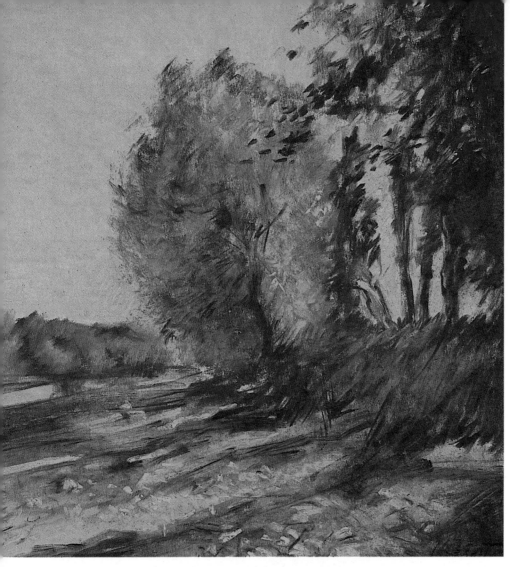

7. *To finish off this landscape exercise, blend the earth tones lightly and apply some direct heavy orange strokes. Finally, paint the large vegetation mass on the right in blue, which will enlarge it a little. This rounds off this landscape. Observe how the background color shows through the tones added and contributes towards the fresh and spontaneous finish.*

SUMMARY

All the support is painted with orange. Holding the stick flat between the fingers allows a light stroke through which the pastelcard color can be perceived.

When orange is painted over blue, a part of the lower color is dragged and so creates tone changes and mixes.

The contrasts are painted in blue, a color which is perfect for creating the backlight effect.

The orange applied with a direct jabbing stroke increases the luminosity of the ground: the tones contrast more intensely.

Animals

OUTLINE DRAWINGS AND SKETCHES

Pastel is an ideal medium for all types of sketches, especially for drawing animals. The two reasons for this are the similarities pastel has with drawing and the possibilities that the method offers for using all types of marks and strokes, so useful in creating form. In this topic we are going to sketch and paint animals with the effects offered by the pastel stick. The secret of good painting is not just in the stroke but in the way you use it.

Animals are one of the most attractive subjects to depict, whatever the drawing or painting medium or method. Top quality results can be achieved with pastel because stumped marks combined with stroke effects permit all types of skin or feather textures. In one of the previous chapters we already painted a bird, and in another a horse. We advise you to go back and check on the process before attempting the more complex examples. The exercises show how in this topic, animals, just like all elements from nature, can be rendered in very simple straightforward forms.

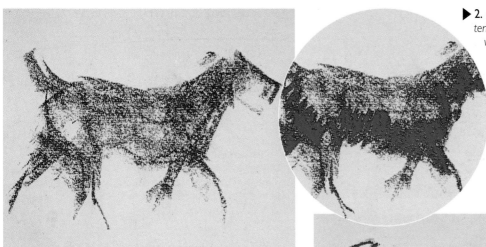

▶ **2.** *Outline the most characteristic areas and suggest the volumes through dark tones. Before working on the final texture of the skin or hair, the direction of the light source has to be decided. You can show this effect by increasing the darkness in the shadow areas and by using pale tones in the light areas.*

▼ **1.** *The stick held flat between the fingers allows a substantial variety of strokes. To paint certain types of animals it is best to start by doing preliminary sketches with the stick held flat. Rapid gestures can insinuate the shape of the animal. The first issue to be considered when drawing or painting animals is the stroke that structures the back and the proportions of the forms. This sketch has been entirely drawn holding the stick flat between the fingers.*

3. *The sketch can be finished off by tracing in some important lines. It is not necessary to completely draw the animal's outline as some areas are adequately suggested by the original strokes.*

COLOR

There is nothing better than painting animals to put into practice a thorough colorist technique. In this exercise color will play the most important part. To start out, it is necessary to remember that colorism is a pictorial technique which depicts shadows with pure colors, not tones or gradations. In a technique like pastel, in which the colors are applied without mixing, colorism is one of the soundest options.

▶ 1. *In colorist painting, the color of the paper is important: you can start from a complementary color. Here, as a base, the paper color chosen is going to stand out intensely against the other colors. The first lines are for the preliminary sketch, and then you must tackle the synthesis of the forms, here oval, expressing, as far as is possible, the anatomy of the animal in pure geometric shapes. When doing the preliminary sketch you have to use a color close to that of the paper color so that corrections do not stand out too much.*

▶ 2. *Once the preliminary sketch has been finished, go over the principal lines and give form to the drawing, preparing it for the color additions. In this stage you can use the stick either flat or on its tip, depending on whether you want to do a shading or a stroke for the outline. Now you can add dashes of colors which will later be blended with highlights or color contrasts.*

> Practice with color. This is the only way of overcoming your uncertainty. Testing out colors on papers that you use for painting gives good results.

▶ 3. *On top of the defined base and the insinuated colors, add many more accentuated strokes and shading, using the under layers as base marks. Place the brightest colors opposite the darkest so that they mutually strengthen and complement each other. Instead of doing tone alterations of the same color or gradations, use a variety of luminous colors to depict the different planes and the feather texture. It is vital that the lower colors show through the new top strokes.*

LINES, HATCHING AND SHADING

Combining effects is the basis of painting animals. In previous sections we have seen two different aspects of depicting animals: sketches and working in color. As will be seen, the expression of a painting must not reside only in the language of lines and shading. The true interpretation of forms and textures is achieved through a balanced combination of painting styles.

◀

1. In the initial layout we saw how a flat stroke can easily outline an animal. This will be the base on which we build. At this stage the characteristics of the stroke marks do not matter, but the quality of the form outlines do. Once you have made the stroke, blend it into the background but without blocking out the drawing.

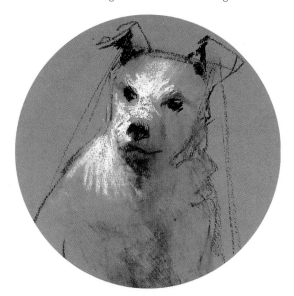

▼ *2. Shading can be a perfect base on which to paint animals. Suggesting shapes through shading and hatching often stimulates the imagination and helps to associate a stroke with the image sought after. Once a shading has been put down, you can go over it with a more direct stroke, but do not allow the form outline to become blurred.*

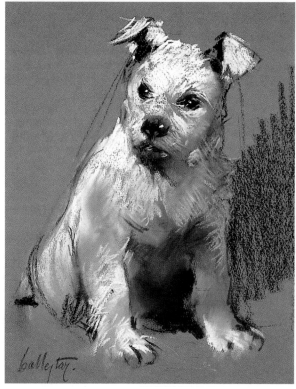

◀

3. When you come to the end of this exercise, try to achieve an equilibrium between strokes, hatching and shading. Some areas are left insinuated. Alternate completely defined strokes with contrasting stumped strokes that have blurred, diffused edges.

A COMPARATIVE STUDY OF TWO ANIMALS

The aim of this exercise is to learn how to construct the structures of different animals. Comparison is always a good tool for learning how to paint, if you have a discerning eye. When animals are compared, the first place to focus your attention is on the relationship between the head, the torso and the legs of each animal. The layouts reveal important differences in their proportions.

▼ In this example which was developed in the same way as shown on the previous pages, you can appreciate how the horse's back has been constructed. A flat stroke has been used to make the long, curvy neck line, which naturally joins the back and hindquarters.

Here you can see the two animals completely finished. Studying them reveals considerable differences, both in the legs and in the proportions of different parts of the body. It is important to notice the joints of the legs; each animal has a different build. ▲

The cow follows the same pattern as before. However, the cow's neck has a different shape to the horse's. The sizes and shapes of the heads are also distinct. Even at this stage the most evident differences between the two animals can be appreciated. ▲

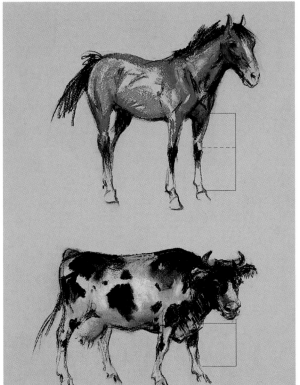

Step by step
A horse grazing

Painting animals is one of the most complicated themes that can be attempted, not only in pastel but in all media. However, pastel is very suitable for animal studies because its direct application means that it is similar to drawing in issues of technique. A very intuitive style is made possible. In this exercise, we propose painting this beautiful horse. Pay close attention to the process right from the beginning. Although it does involve greater complexity than the previous exercise, developing the picture will not be especially problematic if you do it systematically.

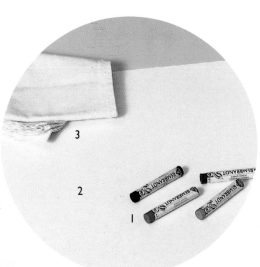

MATERIALS
Pastel (1), white paper (2), and a rag (3).

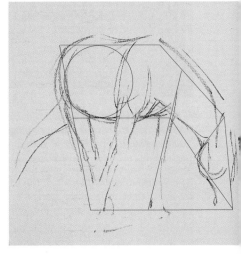

1. *If the beginner is not sufficiently experienced, it is advisable to do as simple a layout as possible on the paper so that the structure is well set out and allows sure and accurate work. Do a preliminary sketch so that you have a guide. The horse fits into the square which, if it is divided up, allows you to plan the principal forms.*

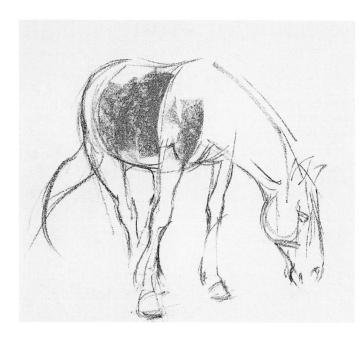

2. Building on the preliminary sketch, go on to do a well-defined drawing. Use hatching to detail each of the horse's body parts, as well as its features. Holding the pastel flat between the fingers, start to paint its body. Rapidly depict its volume with curved strokes defining some areas of the anatomy, like the hindquarters or the front leg thigh.

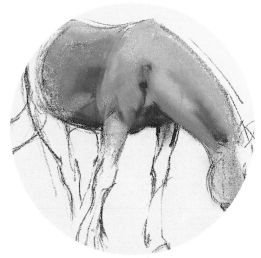

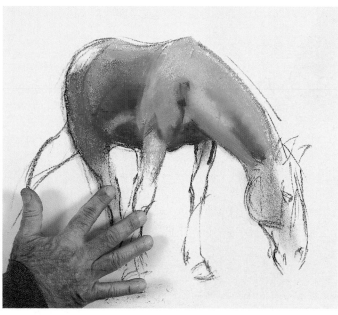

3. It is important not to use just one color to do the shading of the horse. When you paint you already have to be thinking about which tones you are going to use next. Bear in mind that blendings between colors allow a very smooth transition between tones. If you start with a sanguine color tone this new application will be much more luminous and orangy. Paint the darkest black areas with gentle strokes on top of both tones. Use your fingertips to blend these tones, while at the same time seeking to model the forms.

4. If you observe how the animal is positioned you can appreciate differences in the highlights on the hindquarters. This area should be painted with a dark tone of the same range that has been used for whole the horse. Darken the lower part of the horse's belly, making the highlights more evident by using the effect of the simultaneous contrasts. To do the clearer tone of the horse's knee, drag some of the color towards this area with the aim of graying it a little.

5. *Use black pastel to paint the densest contrasts; these are the ones that finish off the outline of the horse's forms. Paint the mane, the dark parts of the legs and the tail black. Contrast the modeling of the horse's belly with the fingertips smudged in black pastel. Afterwards, start painting the highlights using a pale gray color.*

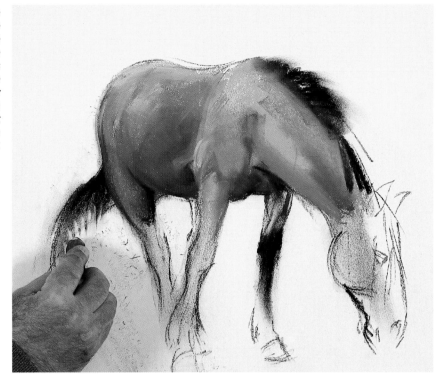

In any pastel work the first step you take must be focused on the forms and color areas. The contrasts and the details are left until the end.

6. *You have to continue painting the areas that require a more gutsy contrast in black and blend the tones with the layers beneath. The exact color of the lower parts of the legs is achieved by blending the black to make it similar to the paper tone. Repaint some areas, like the hindquarters, with direct touches of an earth red color.*

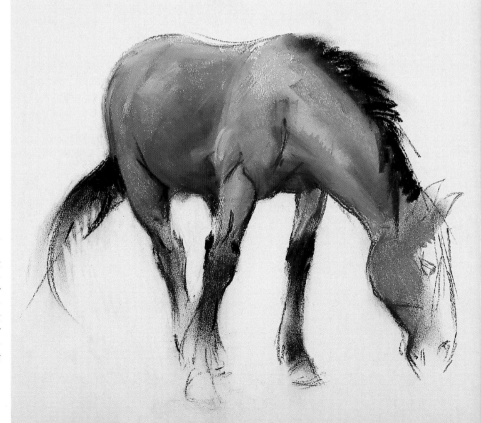

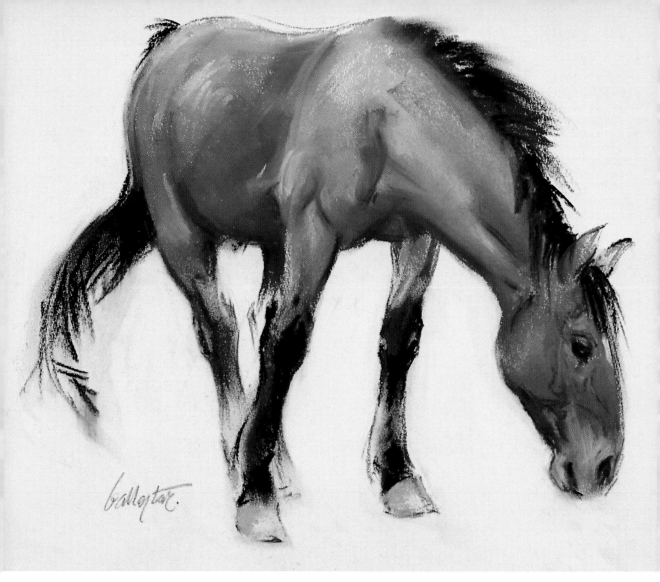

7. *You still have to complete the horse's head. Use the same technique of modeling, blending and contrasting the rest of the body. However, in this area you have to be especially careful when adding shadows. Paint the dark parts last and then*

blend them softly with the fingers. Finally, paint the mouth in a pale tone which you then blend on top of the previous tones. To highlight the details always avoid completely obliterating the characteristics of the stroke.

SUMMARY

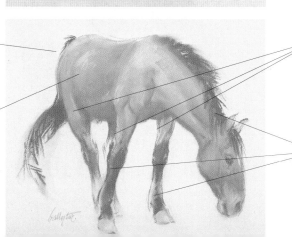

The layout must define the forms starting from simple geometric shapes.

Do the first color applications on the horse's belly. The stroke direction aids the form modeling.

Make the highlights on the legs by softly dragging a finger over the white of the paper.

Use black pastel to paint directly over the dark areas of the animal, such as the legs.

Skies

THE COLOR OF THE SKY

There is not just one color in the sky: any color under the rainbow can appear in the sky at sometime. The atmosphere, the time of day and the weather conditions are all influencing factors on the sky's color. On the following pages we will give some notes which will help you to develop a wide variety of skies.

> The sky is one of the most important elements in the landscape, although, in fact, it is a subject capable of being painted on its own, or with other elements. Here, we are going to do skies at different times of day, and under varied meterological conditions. Painting skies is very creative, and offers the possibility of showing off the versatility of the pastel technique.

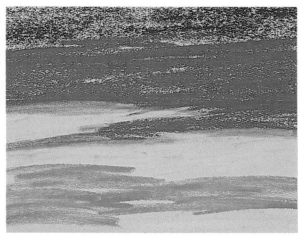

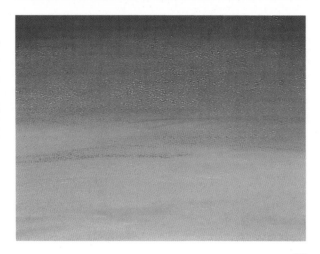

▼ 1. *You can paint a sky using various colors that form a gradation. To start, it is judicious to order these colors naturally, perhaps exaggerating the more realistic ones. However, often it is not really an exaggeration for nature can be wilder, or more spectacular, than the palette of any painter. In theory, the colors have to be conceived without blending or overlapping the tones.*

▼ 2. *With your fingers, blend in all the sky areas. The blending order is important because some areas must be blended but kept clean. In this example you have to start blending at the top. Gently blur the edge between the colors so that the change is subtle.*

3. *Once you have done the tone blending, you can start on some direct details with the tip of the pastel stick. These precise additions enable you to intensify highlights and make some areas of the sky brighter than others.* ◄

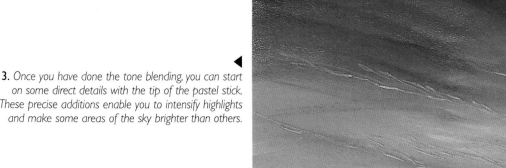

▶ **1.** *To start a clear sky, first tackle the upper tone, which is nearly always the darkest and purest. This is due to the atmospheric layer which increases as the horizon is neared. Below this first color band there are others which form a tone gradation. It is essential that the color situated just under the horizon stands out for its luminosity. It is at this point that the atmosphere becomes thicker and tones down the brightness of the other colors in the sky.*

SHADING PALE SKIES. THE HORIZON LINE

The most straight forward skies to paint are clear, or nearly cloudless, skies. In this case, the color stroke is especially delicate for the skies, as was seen in the last exercise, and can be enriched by numerous nuances. On this page we will do a clear sky and the color change as it approaches the horizon line. It is a simple exercise that will allow us to resolve a host of situations in landscape paintings.

▶ **2.** *Just passing the fingers gently over the sky areas is sufficient to convert the sky into a homogeneous color mass integrated with the other colors in the picture. You must be particularly careful when going from one tone to another for clear or luminous colors can easily be contaminated by the dark ones in the upper part.*

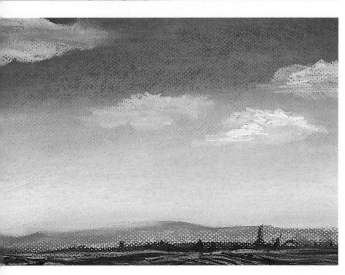

▶ **3.** *The final tone nuances add luminous dashes to the whole range of gradations. Starting from this color base, numerous modifications can be made such as can be seen in the bottom picture where some clouds have been superimposed. Another important question is the treatment given to the whites. Only apply pure white in the highly luminous areas.*

CHANGING SKIES

We have already said that the sky changes throughout the day in a continuous process. In this exercise we are going to do three different skies of one landscape at different times of day. The first is at dawn when the horizon is tinged with red tones. The second will display the luminosity at midday with yellow nuances on the horizon. Lastly, you will paint an evening, almost night time, sky in which the deep blue tones are almost mauve.

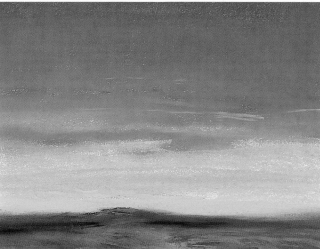

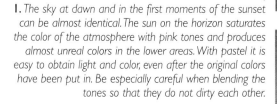

1. *The sky at dawn and in the first moments of the sunset can be almost identical. The sun on the horizon saturates the color of the atmosphere with pink tones and produces almost unreal colors in the lower areas. With pastel it is easy to obtain light and color, even after the original colors have been put in. Be especially careful when blending the tones so that they do not dirty each other.*

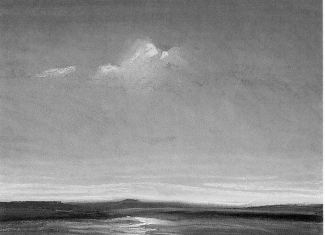

2. *It is at midday that the sky is full of light. The blues become rich and pure. On the horizon, depending on the day, tone changes can be observed. On very hot days, in some areas, dust particles hang in the air giving a reddish and yellowish hue.*

3. *Dusk always presents a display of very contrasted tones. The colors of the night, deep blues or violets, are contrasted with the remains of the day's colors. These final rays of sunlight are represented by luminous pastel strokes that tint the sky with pinks and oranges. Here, too, you must be careful when blending the tones because it is important to maintain the vitality of the luminous colors. Paint, blend and superimpose these tones saturated in light at the end.*

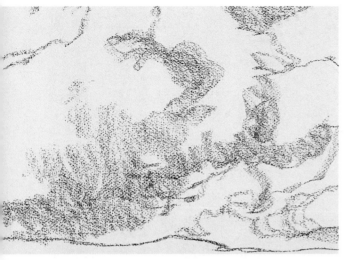

CLOUDS

Clouds come in many shapes, colors and textures. Despite the appearence of their capricious forms, the condensation does not happen randomly. This process divides the clouds into three groups: cumulus, cirrus and stratum. The altitude of the clouds, their density and the time of day mean that more or less sunlight passes through. Thus, some areas are illuminated while others remain dull. In this exercise we are going to paint some stormy clouds. Pay special attention to the tone blending and the maximum tone contrasts.

▶ 1. *The choice of paper is an important question if you want to take advantage of its color. In this example gray will help you to depict stormy clouds. In this exercise we are not going to allow any glimpses of the sky to show through. Therefore, what you have to work on is the clouds. The first step is to draw the forms of the storm clouds and then you can start to think about adding dark and light areas.*

▶ 2. *Paint the most luminous tones but leave the centers unshaded to take advantage of the paper color. These tones can be ivory white, pure white, or even Naples yellow. You can also start on the darker tones that correspond to the cloud shadow areas. As can be seen, the paper color is perfectly integrated into the clouds, although, as yet, the hues have not been blended.*

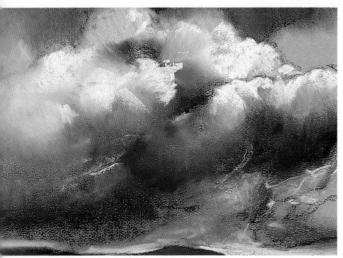

▶ 3. *Blend the dark tones and the light areas on the paper with the fingers, thus permitting the cloud forms to be modeled. Do the modeling with curvy movements which blend the tones into the paper color. Once all the blending has been carried out, paint and outline directly in some areas, while in others add precise highlights.*

Step by step
A sky with red clouds

Painting clouds can be one of the most rewarding and enriching works that you can do in pastel. You do not need to have a very elaborate preliminary drawing to start out. Besides requiring less preliminary work, another advantage is that skies can give spectacular results if you choose the right moment. This model is a fine example.

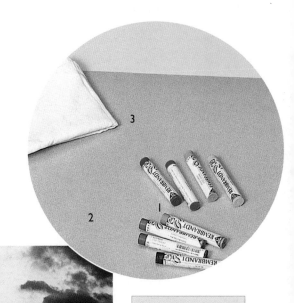

MATERIALS
Pastels (1), gray colored paper (2), and a rag (3).

1. *The preliminary sketch is not as important as it is for other pictorial themes. However, as will be demonstrated in this example, this sketch will be used as a guide to do the planes of the picture and to adequately situate the colors. Do the drawing with the tip of the stick. If you use a clean stroke you will be able to differentiate the land planes from the cloud forms. While the land is characterized by tight, dark drawing the clouds are much more curvy and suggestive.*

STEP BY STEP: A sky with red clouds

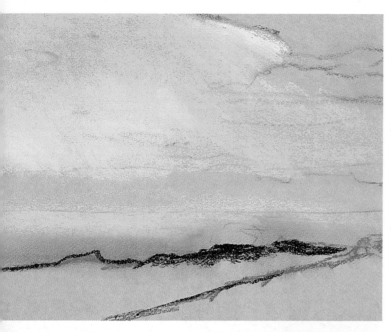

2. *Start with the most luminous sky tone, where the clouds still reflect the sun's rays. These first colors are of different yellow hues which gradually turn into orange tones near the horizon. After doing the initial strokes, pass the fingertips over the work to fade away the stroke a little.*

3. *On top of the orange band on the horizon, paint a very bright pink strip. Use pale violet on the lower part of the clouds, enriching the tone with a few blue dashes. Pay attention to the new lower band on the clouds. Draw a fine blue line on top of the pink band and then blend it with the fingers until you obtain a precisely located dirty tone.*

4. *Paint all the lower section, where the mountains are, with a very direct style in black. However, in the lower part of this plane, gradate the black and blend it into the background with a dash of Prussian blue. This will differentiate it from the tone beneath. Apply dark tones to the sky; black in the upper right corner and blue in the spaces left by the yellow shading. Blend some parts of the sky, always aiming at blurring very defined areas.*

5. *Paint the darkest parts of the sky gray. Make the contrasts with the most luminous tones stand out by placing them next to lighter areas; these are not in white, but rather very pale variations of Naples yellow. Paint the shining sun with the shading technique, in yellow, Naples yellow and orange. Do the foreground in a very deep black tone, as a good contrast for the gradation you did before.*

6. *Paint on top of the yellowish clouds with much more luminous tones that are superimposed over the dark parts of the picture. Where you have painted some areas blue, you must now darken them with black pastel. The bottom right corner of the land is painted with a blue hue which you should blend with the black. The base color is ideal for continuing to do different luminous details. Three distict styles can be used: very direct jabbing strokes, straight lines or little dashes to blend everything together, smudging, on top of the lower tones.*

7. *A bone-colored tone gives the final, very direct, touches to the highlights in the sky. Further soften some areas on the left by incorporating a very luminous* *pinkish color. Finally, you have to paint the sun and the glow around it. You have now finished this impressive sunset sky.*

SUMMARY

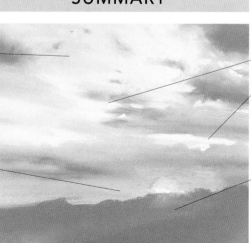

Apply the brightest and boldest colors first before going on to superimpose the top darker tones and contrasts.

Paint the band near the horizon in orange and pink hues and then blend them into the first layer of color.

Paint the impacting light last of all. Do not blend all the areas. Instead leave them fresh and direct.

Paint the most striking dark parts black, a color which boldly contrasts with the most colorist sky areas.

Trees

THE STRUCTURE OF TREES

It is important to be familiar with the internal structure of objects before starting to depict them on paper. As we have studied up until now, all forms and objects of nature can be represented by working from straightforward geometric shapes. A tree can also be seen in this way. The synthesis of its forms is much more obvious than other things in nature.

Trees are often elements that give the landscape a lot of its character. Sometimes they are an important part of the drawing and need to be highly elaborate and detailed. At other times, you can define them with simple green shadings that blends into the background. In this topic we are going to do some examples that will be a model for future exercises. The techniques we use will enable you to paint all types of tress in any landscape.

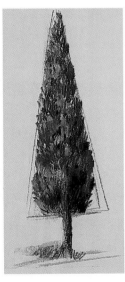

▼ We are going to use a triangular shape on numerous occasions to draw perennial trees like firs or cypresses. Before painting this tree you must sketch its form so that you can visualize it more easily. It is important to study the highlights of each one of the tree areas. The shadows help to correctly place the different green tones.

▼ A rather complicated shape can be fitted inside a simpler scheme, which, if you use it as a guideline, can help to understand the internal structure of the branches. As can be seen in this picture, the tree starts from a rectangular shape divided into different sections that allow you to describe the branches and trunk with almost straight lines.

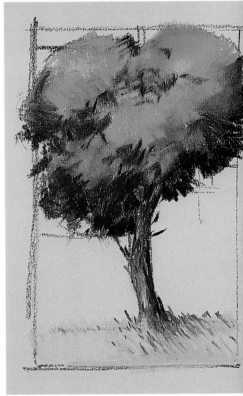

▼ Once you have outlined the general shape of the tree, you can draw and paint the final version. First do the edges, then, the inside of the tree, add the strokes and colors it give texture.

SHADING THE TREE

Shading always adds a sense of landscape, whatever media you are painting in. After the preliminary sketch the color shading helps to guide the whole process. In this exercise you can appreciate in detail how to use a correct shading technique so that the contrasts are supported by the light and dark tones. The direct style of the pastel stroke means that a broad variety of shading options which prepare for light or shadow areas, and the final texture and touches, are possible.

▶ *1. When you have finished the preliminary sketch, start the shading of the tree. The pastel stroke offers you the possibility of doing either flat lines, with curvy movements, or using the full width of the stick. This is why the first colors added always acquire a markedly drawing-like quality. The lines that start the shading of the tree are principally aimed at setting out the volumes. A tree, unless it has a perfectly pruned form, can come in a multitude of shapes, each one with its own light and shadows.*

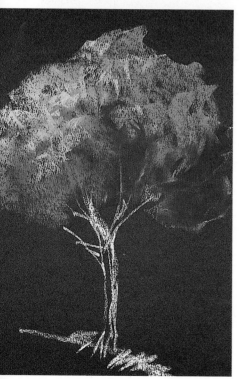

▶ *2. Once you have set out the first dark parts, you can paint the brightest areas. In this example, as the paper is colored, white stands out forcefully. Continue to shade the tree with your fingertips, making the stroke mark less visible and blurring the edges of some areas. In other areas the stroke is left visible. It is important to remember that you do not have to stump all the tree.*

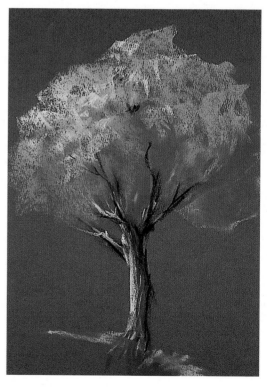

◀

3. After the shading with your fingertips, you can start to finish off the tree by laying down new tones. Apply some tones directly and spontaneously without any stumping. Blend other hues but never go so far as to mix them with the colors or tones underneath.

PAINTING A TREE

As we have seen, the pastel technique offers an endless range of possibilities, from shading right through to different finishing touches. You can work on a tree in a great variety of methods, blending, shading and using direct strokes.

In this exercise we are going to do a double piece in pastel. We will start working in a fresh and direct style. Then we will study how to resolve the tree texture.

◀

1. *Use green-colored paper. Many areas of it will blend perfectly with the pastel, especially the areas containing green tones. The first strokes to put down are completely drawing-like. Shading is not suitable here, nor is blurring the color. On top of the preliminary sketch, do strokes that gradually merge into other colors, but always maintain the fresh and spontaneous properties of the stroke. You must not make the pastel too pasty, neither must you blend it. Use a completely gestural style.*

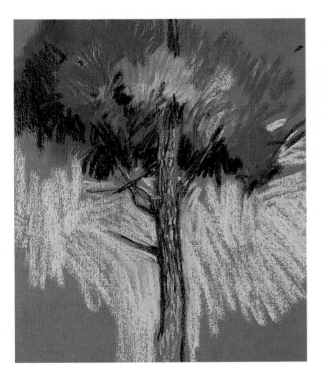

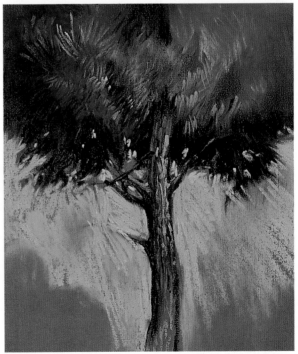

▼ 2. *This early work uses only gestural drawing and the pastel stroke in an attempt to make the landscape real. In this way all the surface can be covered. When you paint the area around the tree in a luminous tone, you will see that the trunk becomes clearly outlined. In the upper part, blend the color of the paper with the tones of the tree top.*

▼ 3. *Hatch all the areas that are going to be the base of other layers. On top of these blended areas, paint darker colors that create contrasts. Re-blend some dark areas, and then, on top of them, add luminous colors. The work that remains to be done alternates direct strokes with the blending of different shades.*

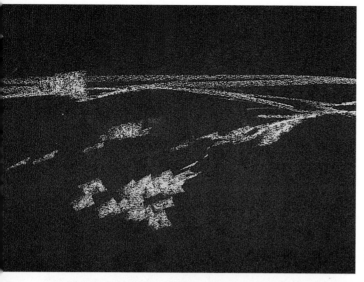

BUSHES AND VEGETATION

A landscape is often covered by vegetation that is smaller than trees, like bushes, thickets and grass. They are portrayed in pastel by combining the two basic techniques of the medium.

Often the details are not drawn in, but they are insinuated by soft stumpings or tone gradations combined with direct tones. In these masses of vegetation, what is really important is the effect of the light areas and the dark parts.

▶ **1.** *When you start to paint a wide area of vegetation you are confronted with the reality that no bush stands out on its own. What is visible is a mass of green shades with some tone differences due to plane changes and deeper shadows in some areas. The way the whole picture is set out is important: it must be treated as one object. You must do the preliminary scheme linearly and you must give volume to the vegetation.*

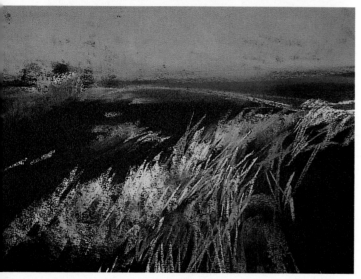

▶ **2.** *Use several green tones to mark the picture in different areas according to the degree of luminosity desired. However, do not go beyond certain well-defined limits. As can be seen, the stroke is sufficiently dense so as to leave an important quantity of pastel on the paper. Put the pastel down thickly so that you can blend it with your fingers, thus giving shape to the different plants and bushes. One important point is that the more the vegetation recedes into the distance, the more the trees and bushes tend to blend into one unique tone.*

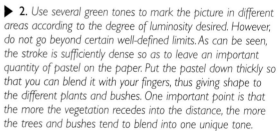

> The color of the paper must always show through the strokes to convey the sense of space and light in the atmosphere.

▶ **3.** *Once the tones have been merged, apply direct colors so that the painting is more contrasted and precise in the shadow areas. Paint free, loose strokes in the areas where light falls.*

Step by step
Trees and vegetation

Portraying scenes in which the vegetation plays a key role is a recurring theme in landscape painting. When you start out, you may think that all vegetation is the same color, but with perseverance and much practice you will soon learn how to distinguish the wide range of nuances that compose a quiet corner like the one shown in the image. There is not one particular rule for painting vegetation. However, you should bear in mind the capacity of pastel to be blended and superimposed if you are interested in carefully laying down different tones in the trees and bushes. Pay special attention to the contrasts you create in the landscape near the lower part of the river bank, and the upper part of the trees.

MATERIALS
Pastels (1),
colored paper (2),
and a rag (3).

1. Here the drawing plays a key role, although it must be very simple. First the far bank is drawn in with a white edge. Over this line all the vegetation area is sketched in. In the tree and background mountain area limit yourself to just doing the outline. The near shore is also now outlined.

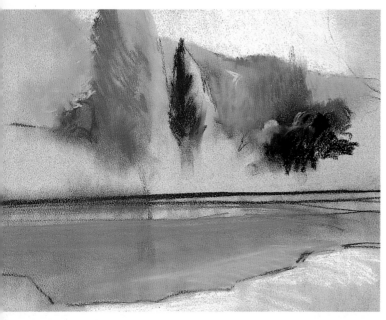

2. With pastel, direct mixing cannot be done on the paper. Instead, paint each tone, whether it be clear or dark, in a pure color from the pastel box. Use a very luminous green in the lightest part of the trees, and a somewhat darker one for the shadow areas. Paint the densest parts with a black slightly mixed with the lower tones. Paint with white in the foreground so that the color of the paper contrasts and blends in like just another color. The sky is painted in white tinged with a little Naples yellow.

3. Blend the colors where the edges meet, but do not mix them. Some colors, for example the violet tone above the bank and the cobalt blue on the right, act as base tones for other colors that will be painted later. The unique area in the picture where the colors mix is on the right. Here a dirtied color is necessary, so paint in a mixture of sienna, black and green. Mix lightly with the fingers so that the colors are completely blended.

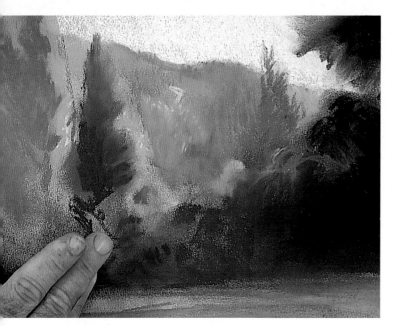

4. Superimpose the colors in the luminous trees on the left. Allow the background tones to show through the darkest strokes. Blend some areas by rubbing with the fingers and contrast the recently painted dark brown tones above the bank.

There is not a unique rule for painting vegetation although the following should be kept in mind: pastel has a high capacity to be blended and superimposed if you want to obtain different tones in the trees and bushes.

5. *On top of the completely shaded background, paint some very defined colored areas. This time do not blend the strokes. Instead, leave them fresh and let the layers underneath show through the gaps. Use dark green to shade above the bank. As can be seen in this image, the stroke must be zigzagged, very ordered and must follow the top of the thicket in this area.*

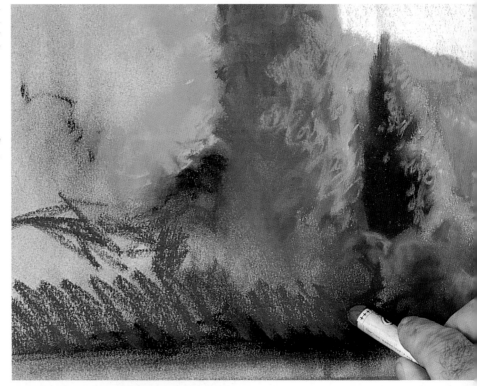

Pay special attention to the contrasts that are established in the landscape. In the final picture they give life and impact to the whole painting.

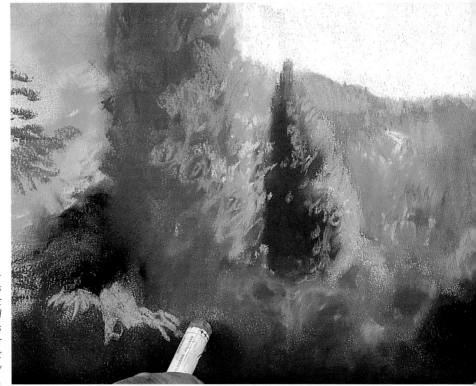

6. *Use your fingertips to completely blend the previous dark strokes. This somewhat dirties the unpainted band beneath the bank. Over this dark area, paint the upper section of the vegetation lit up by the sun with a very luminous green tone.*

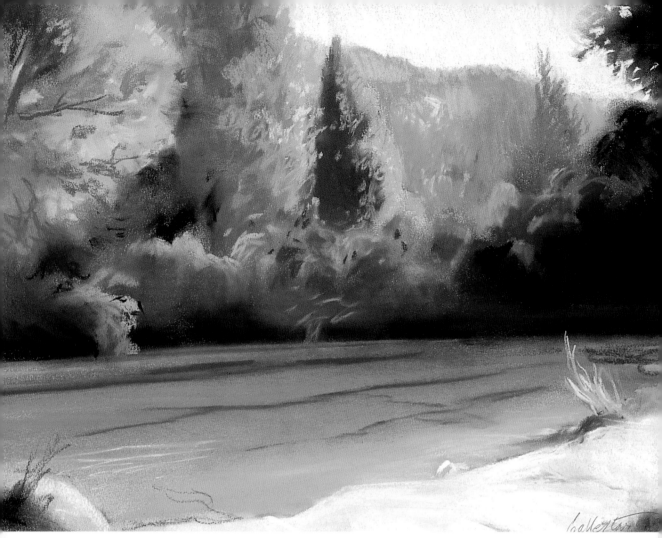

7. *Taking care not to mix the upper colors, blend the light green part of the bank thicket over the dark background. With the same light color used to paint the most luminous area, lay down some new fresh strokes. Paint the left of the landscape in the same way as the bushes along the shore, but this time with much more luminous colors. First, do some shading that blends together. Finally, make some jabbing direct style strokes. After painting a few more contrasts in the foreground vegetation and in the water, you can consider this landscape finished.*

SUMMARY

Before painting the trees lay down a base of blended tones.

The preliminary sketch is very traightforward. Only lay out the general forms of the trees and the banks.

In the foreground, paint in white. The background color of the paper is integrated into the overall effect.

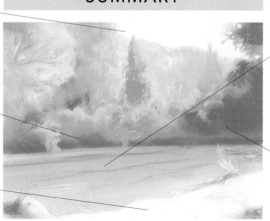

Do the blending of the water area without mixing the colors.

The only color mixing that you do is on the right of the landscape, where it requires a deliberate dirtying of the colors.

Urban landscape and perspective

NOTES ON THE CONCEPT OF PERSPECTIVE

Urban landscape offers many possibilities because any town or city can be depicted from numerous viewpoints. To get the most out of these possibilities it is necessary to understand the principal concepts and rules of perspective. It will not be difficult to comprehend if you pay sufficient attention.

In cities and towns it is common to see artists using streets and squares as models, even in areas that at first sight do not seem to be especially attractive. Urban landscape can be considered as part of the natural landscape theme, although there are differences in the way it is treated and its technical requirements set it apart. One of the fundamental requirements to sketch and compose an urban landscape is the application of perspective, which we are now going to explore.

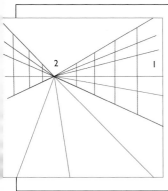

The horizontal line situates the horizon (1). On this line, mark a point called the vanishing point (2). All the lines parallel to each other that run from the viewer towards the horizon coincide in this vanishing point.

If the viewpoint coincides with the horizon line, the viewer is looking from normal eye level in the street. The lines drawn in blue represent viewpoints above normal eye level. At the point where the vertical line is cut by the vanishing line, draw the lines that mark the height of the frontal viewpoints. These lines, just like the horizon line, are completely horizontal.

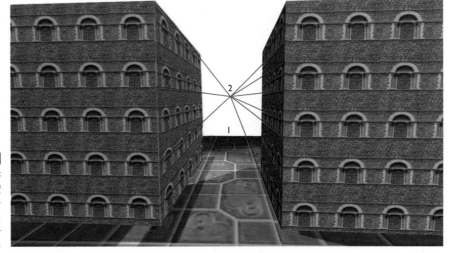

◀ As can be seen in this diagram, the vanishing point (2) has been situated above the horizon line. This implies that the viewpoint is above this level.

PERSPECTIVE AND LANDSCAPE

S tarting from the diagrams and explanations in the last section, we are going to do a perspective exercise in pastel. It will not be too complex, particulary if you follow the images and the steps in the text with attention. As can be seen, only one vanishing point is used and, therefore, all the lines of perspective follow in the same direction.

▶ **1.** *Trace the horizon line. Mark the vanishing point in the center. All the vanishing lines run towards it. Draw several lines that go through the vanishing point. Two of these lines situated beneath the horizon line are to be the base of the earth planes and the vertical planes. Draw the buildings that border the line of perspective with several vertical strokes. Sketch in trees in the avenue between the two lines of perspective. They become smaller as they recede into the distance.*

▶ **2.** *The height of the vertical lines that correspond to the height of the buildings are determined by the vanishing lines. From the intersecting point of the vertical lines and the line of perspective, trace small horizontal lines parallel to the horizon. These lines finish off the form of the buildings. This process can be used to do all types of buildings and streets, always respecting the corresponding heights and depths.*

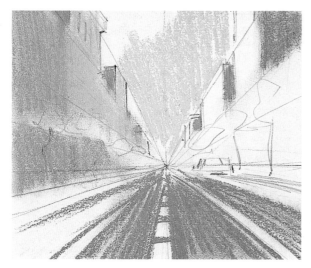

▶ **3.** *Once the principal lines and constructions have been set out, you can start to distribute the principal color areas over the picture. Pastel allows a rapid and fresh work style, although it does not permit the colors to be mixed. You have to find a pastel stick with the right tone. Each plane is going to have a different tone. First, use gray to paint all the road area. Mark off the darkest area of the buildings on the right with a brownish gray. On the left, paint the buildings in an ochre color.*

COLOR AND DISTANCE

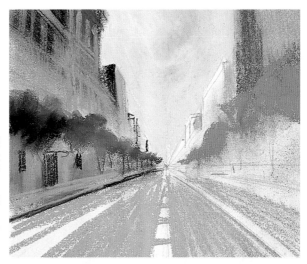

1. *As we have studied, colors can be superimposed over light colors or dark ones, which helps the picture to be developed quickly. Paint the façades of the buildings on the left in orange, except the shadow areas which you can do in an almost black color. On the lightest side of the street, paint the tree tops in a very luminous green. On the darker side, use a darker green. As you paint the tones receding into the distance, you can fade out the details and the building contrasts, too.*

> The colors are can be superimposed on top of both clear and dark colors, allowing the picture to progress rapidly.

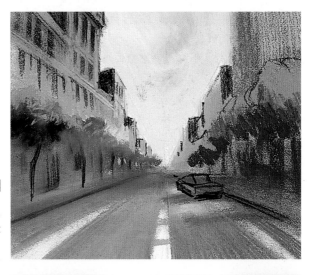

2. *As the objects recede into the distance, nearing the horizon, they appear smaller and more blurred. The lines that run to the vanishing point indicate how much smaller the trees must become. The trees in this exercise can be painted using this guide. The further away the trees are, the less details you have to put in.*

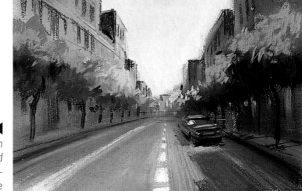

3. *The features of the objects in the distance are also done in a very undetailed way. Observe how the traffic signals painted on the tarmac become smaller as they run towards the vanishing point. Lastly, apply the deepest contrasts to finish off the definition of the remaining objects in this urban landscape.*

THE VIEWPOINT

The viewpoint allows a landscape to be depicted from different heights. A high viewpoint places the ground plane below the spectator in such a way that they observe the landscape looking down. This exercise presents an urban landscape viewed from the peak of a mountain overlooking the city. You must study the direction of the lines of perspective carefully as well as the effect produced when a plane in the foreground is situated between the viewer and the landscape.

▶ 1. *The preliminary sketch must take into account the viewpoint. In the first layout, the horizon line has been placed high up so that it coincides with the viewpoint. One is looking down from a high viewpoint on an extensive area of land and sea. One of the effects that can help to portray this type of perspective is placing a plane at the same height as the viewer. In this example, on the right a piece of ground at the same height as the viewer has been sketched in. You can use very clear tones to paint the sky, taking advantage of the paper color.*

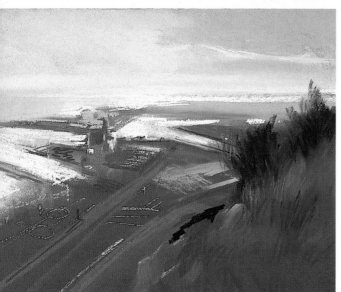

▼ 2. *The colors in the distance tend to tone down the contrasts and to merge together, especially when the atmosphere is dense. In this urban landscape, you can observe the color differences between the way the foreground has been resolved and the background planes. To intensify these differences, the background colors are whitish and outline the breakwaters in the port. Paint the land in the foreground with very contrasting colors.*

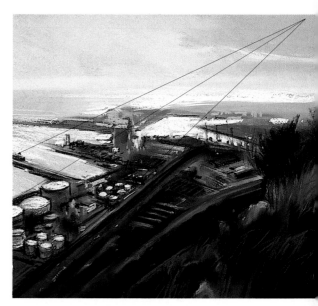

▼ 3. *Observe how this high viewpoint has been resolved. Placing perspective lines gives a sense of distance. The color of the paper also plays a fundamental role since with just a few luminous strokes and some defined dark contrasts, all this industrial port has been depicted.*

Step by step
Urban landscape

You can use any corner of the city as a model for painting. Even obviously sordid areas often make for highly interesting pictures. To get satisfactory results with an urban landscape, a good perspective drawing technique can be the key. In this exercise, among other points, we introduce straightforward effects which can be used to paint urban landscapes. To put them into practice there is nothing better than a busy city street. Long, straight thoroughfares are ideal to develop perspective and the vanishing point.

2

NECESSARY MATERIALS
Pastels (1) and paper (2).

A good technique for drawing perspective is essential for getting satisfactory results from an urban landscape. This is, without a doubt, the fundamental key to the development of a good painting.

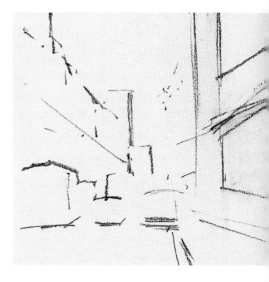

1. *In the diagram the lines of perspective have been set out. Mark off all the building planes, both the upper and lower parts, with lines that recede towards the vanishing point, situated on the horizon. To do this preliminary sketch, it is not necessary to put down strongly marked lines. However, if you are not very skilled in drawing you can do a series of perspective lines that will help you to layout the planes. Do this linear diagram by looking at the direction in which the sidewalk, the base of the buildings and the building tops point. The vanishing point is located where these lines intersect.*

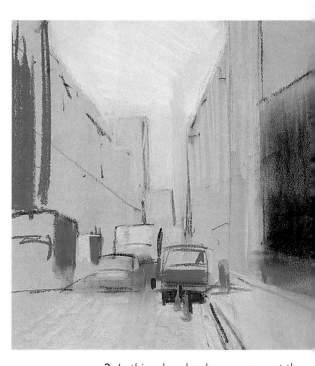

2. *Once this part of the drawing is finished, paint the sky area; first use a very luminous yellow color that creates a strong contrast with background. On top of the base color do white shading and then run your fingers over it to blend the white and the yellow. The result is a dense color, typical of city fog or smog.*

3. *In this urban landscape we want the color of the paper to function like the other colors in the painter's box. In some places allow it to show through in such a way that the colors and tones create an interesting effect. Shade the darkest buildings with a dark pastel color and, immediately afterwards, blend this tone with the fingers so that the walls have a typically dirty city look.*

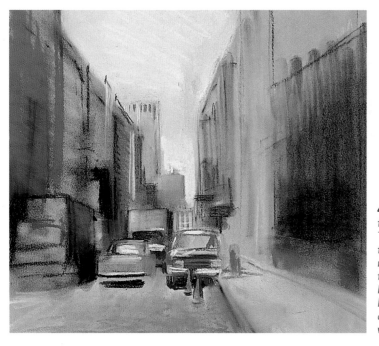

4. *The most distant buildings are less contrasted than those in the foreground. Therefore, use a very luminous bluish gray tone on them. Outline the parts that must remain bright in a dark gray. These sections go well with the color of the paper. Make the highlights stand out with clear luminous gray strokes. Apply a deeper color on top of the dark gray of the sidewalk and then blend it with your fingers.*

5. *Taking advantage of the color of the paper enables us to obtain an atmosphere with very realistic light. On top of the dark parts of the buildings on the left, paint a few pink dashes. Use very dark gray to outline the warehouse entrance on the right. It is then made to stand out with a luminous tone. Paint the cars with small dark strokes, not pressing too much. On top, apply little touches of shading to strengthen the highlights.*

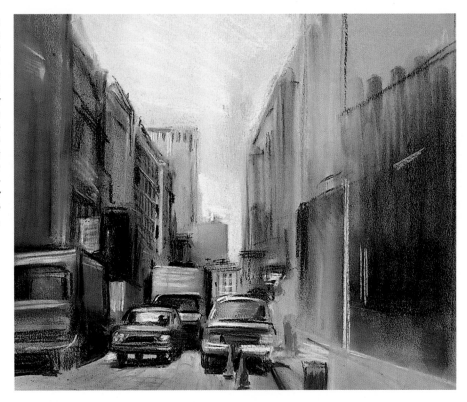

6. *Add a few yellow dashes to the buildings on the right so that the picture soaks up the openness of the sky. Use a very bright cream-colored pastel to paint the warehouse windows on the right. Perspective once again is highly important: observe how the window lines follow the same direction as the rest of the vanishing lines. Add new, almost white lines to suggest the shape of the windows.*

To merge the colors it is necessary to rub vigorously with the fingers. Do not be afraid of staining your hands.

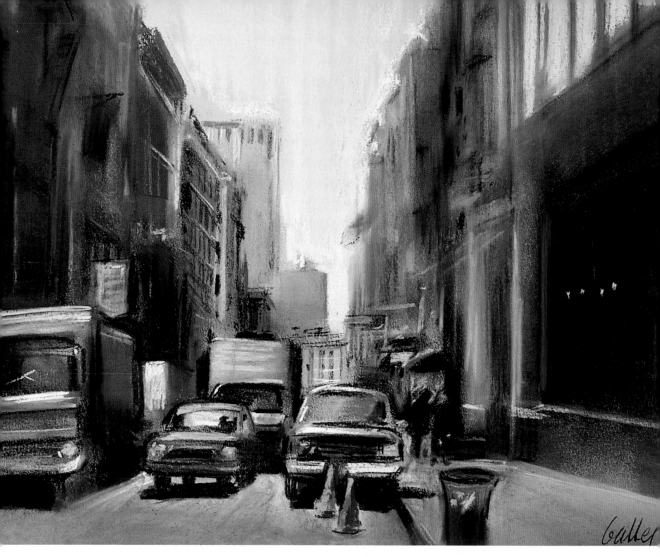

7. *In the upper part of the left-hand side buildings blend the tones with your fingers to make the strokes painted last less prominent.*

This also enhances the effect of the heavy atmosphere and the sensation of distance. These details finish off this pastel urban landscape.

SUMMARY

Firstly, paint the sky yellow. This immediately integrates the color of the paper color into the theme being painted.

To indicate the perspective of the planes, the lines of perspective must recede towards a point on the horizon. Two lines that start off parallel tend to intersect at **the vanishing point.**

The most distant plane is much less contrasted than the buildings in the foreground.

Use dark gray to stump the buildings on the right in the foreground. The color of the paper always shows through the stumped tones.

Still life

SETTING OUT THE ELEMENTS

Throughout this book we have looked at different questions related to still life. All of them were vital guide lines for doing any pastel painting well. In this chapter we are going to explore some concepts such as how to lay out the elements in a still life so that the picture composition is harmonious and balanced.

A still life is one of the most interesting themes that can be developed in pastel because of the techniques used and the many ways it can be elaborated offering far ranging possibilities. Moreover, it permits a thorough study of the forms and color, while the necessary techniques are not so difficult as for figure or portrait. Even beginners can produce good results with still life, whatever their level. This chapter deals with some general concepts related to still life in pastel.

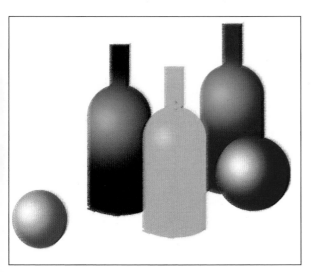

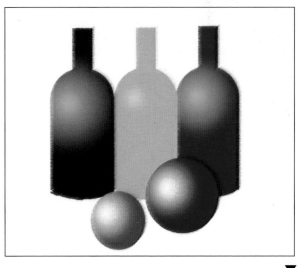

▼ It is important to arrange the elements of a still life well. In this image you can see that they have been correctly laid out. If one of the objects is moved, here the sphere has gone to the left, the group on the right is still well balanced.

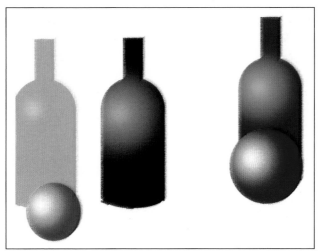

▼ Here the same elements are presented but their distribution is not pleasing to the eye. The error is that they are excessively crowded. The line-up is too harsh.

▶ When you are seeking a certain balance between the forms you could fall into the trap of making the composition too dispersed. In this picture the objects have lost their unity: there is no equilibrium between them so the final composition does not hold.

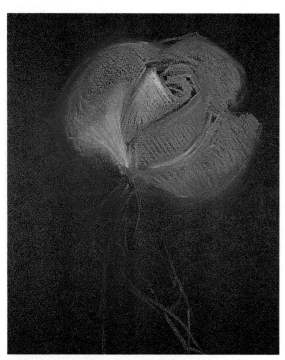

INITIAL SHADING AND OVERLAYING STROKES

The painting of some objects in a still life can be achieved directly on the paper. The technique allows corrections to be made immediately, either by flicking the stroke with a cloth or covering it up with another stroke.

Here we are going to do a flower, alternating the two principal pastel processes. Start the work with rapid strokes that outline the principal forms. It does not matter if one stroke overlaps another. Pastel allows you to change the drawing style from pure strokes to a more painting-like style, using the stick flat to do impacting colors.

▶ *1. After you have drawn the flower, shade the interior. Alternate using the tip of the stick with the flat stroke which allows you to cover the surface much more quickly. As you progress with this area, start to reduce the harshness of the strokes. Gently rub them with the fingertips. You must work lightly so that the color surface is not completely blended.*

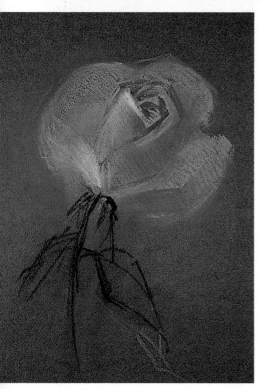

▶ *2. The light and shadow planes in pastel are resolved very easily. It is merely a question of applying a lighter tone on top of the already painted tone. This will separate out the light planes of the object. The edges of the petals are drawn with small touches of a very luminous color on top of the pink of the flower. The clouder tones allow the separation of the planes inside the flower and at the same time you can work on modeling the forms.*

◀

3. Do not mix to obtain different tones, neither light ones nor dark ones. Do the darkest shadows by painting over the lower color with a darker one.

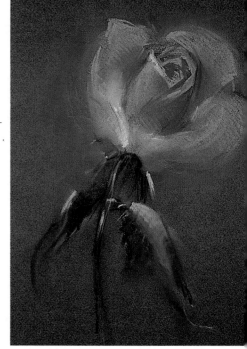

TONAL VALUE

In other chapters pastel has been used to bring the best out of values, tone gradations and blendings. You can do several effects without the need to blend the colors directly with your fingers. If you want to lessen the visibility of the stroke you can give little flicks or rubs with a brush. This technique for semi-blending the colors can be used together with tonal values.

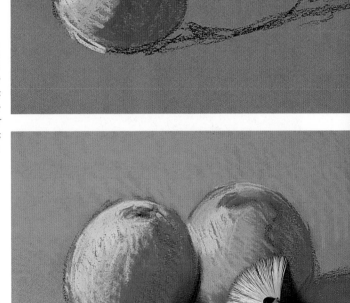

1. Once the model, here a still life with two pieces of fruit, has been drawn, you can start to paint the background in green cross-hatched strokes. Outline the apples with this color. After painting the background, move on to shading the apples. The shadow colors are much denser and warmer than the highlight areas. The color of the paper sometimes shows through between the recently painted strokes.

2. Once all the colors have been put in, take the fan brush and start to gently blend the color. However, be careful not to push too hard because the brush removes the powder quite easily. When the brush is passed over the painted surface, the colors merge in a gentler way than with stumping or with the finger. The stroke does not blend completely.

> Depending on the brush you use, you can produce different diffused effects. Some special brushes allow you to do very detailed work.

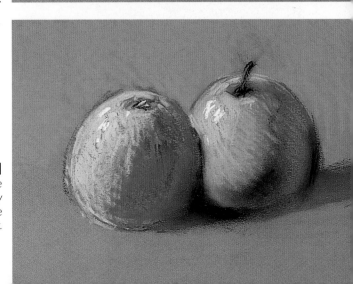

3. In this exercise which is full of light and color, not only is the use of the brush important but the direct impact strokes also play a key role; they combine perfectly with the stumped areas to give the necessary final contrasts which define the forms of the fruit.

HIGHLIGHTS AND REFLECTIONS

Highlights and reflections in a still life can be painted in several ways. It is always important to take into consideration that pastel can be painted with blending or with direct strokes of light. In this exercise you will be able to see how precise highlights are made on glass.

▶ **1.** *Right from the first moment pastel requires a well-constructed design drawing, especially when you do little painting work. You can do the drawing, which is always the base for any reflection or highlight, in light or dark colors, depending to a large degree on how much the line is to stand out on the paper. The stroke must be as clean as possible, although if you make a mistake you can erase it. Paint the most luminous highlight in white just below the center of the glass.*

▼ **2.** *The tenuous highlight in the center is resolved by gently blending the color. On top of this, inside the vase, paint the reflections in the water. The green color of the paper is reserved by the other tones, integrating it into the overall color effect. Alternate tone blending with direct pastel strokes.*

▼ **3.** *Working on the base of the defined contrasts, do the final forms with small highlights and precise dark areas in different areas of the picture. Paint the most heavily shadowed part of the glass in black. Next to it, make a small highlight which contrasts the glass shape against the background. Finally, paint the brightest parts, like the reflection on the edge of the glass or the highlights in the finger, with direct color strokes.*

Step by step
A still life of fruit on a plate

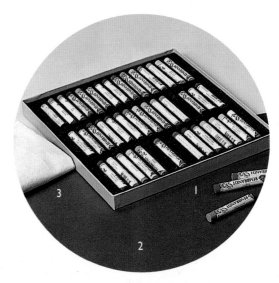

The still life proposed here is not very complex. However, you must pay close attention to the initial layout as the colors of the objects greatly influence each other. You will also learn that it is easier to represent any fruit than to do the precise curve of the plate. Looking closely at the model, you can see the soft fruit shadows that create an effect with the adjacent colors. Despite these complications, it is not difficult work if you pay close attention to the steps outlined in this exercise.

MATERIALS
*Pastels (1),
colored paper (2),
and a rag (3).*

You have to take great care of the model. Both the colors and the positioning of the fruits will have an important impact on the quality of the work.

1. *Before starting to paint it is important that you do as good a drawing as possible. Do the preliminary sketch in dark pastel. The most complicated form is the plate, so be prepared to dedicate time to it. You can correct it by laying down more strokes until you get its shape right.*

STEP BY STEP: A still life of fruit on a plate

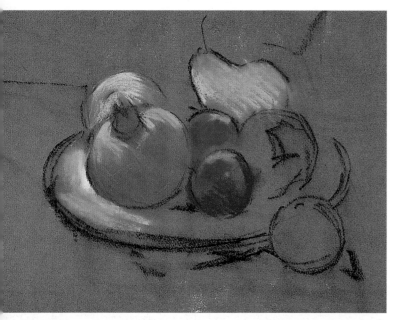

2. *Before starting on the color, fade the drawing a bit with a cloth so that the dark strokes do not contrast too much. Paint the darkest tones on the fruit: dark orange for the pomegranate and violet carmine for the shadow tones on the plums. Paint the light part of the plums with a violet pink. Do the most luminous colors on the pear and the apple with a yellowish stroke.*

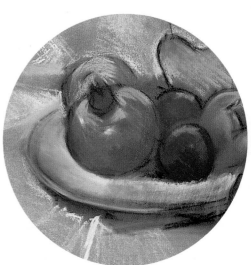

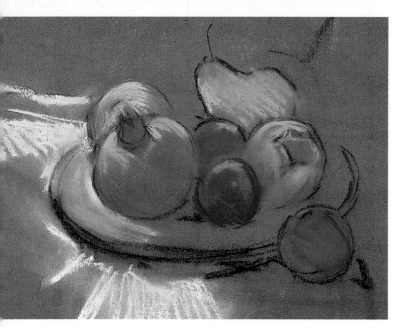

3. *Paint the plum on the table in a very brilliant pink, and the pomegranate pink, orange and green. The colors in this area are gently blended with the fingers. Paint the tablecloth a very luminous white which stands out against the background. Use firm strokes at the beginning. Draw a radial stroke outwards from the plate using the tip of the pastel stick.*

4. *Remove any excess pastel on the table-cloth by gently flicking with the cloth. Paint the edge of the plate and the background in a very light cream color. However, do not allow the color produced to be too contrasted. Paint the pomegranate on the left with a very bright orange tone. All these touches will ensure that the contrast between the object colors and the background is finely compensated.*

> The most precise forms are always the most complex ones, especially compared to pieces of fruit as the latter allow a margin of error.

5. *Do each dark part of the fruit in a different color. The colors of the pomegranates are reflected onto the other fruits around them, and vice versa. On top of the dark parts of the pomegranate, do pink tone shading, and on top of the plums shade with blue shades and a light orange tone.*

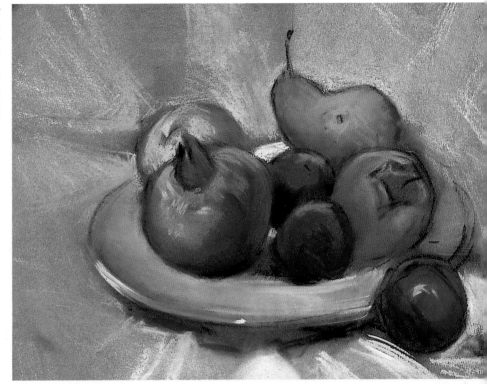

When you move on to do the dark areas and the areas in shadow it is important to remember that not all of them will have the same tone. Each shadow is affected by the color of the object reflected.

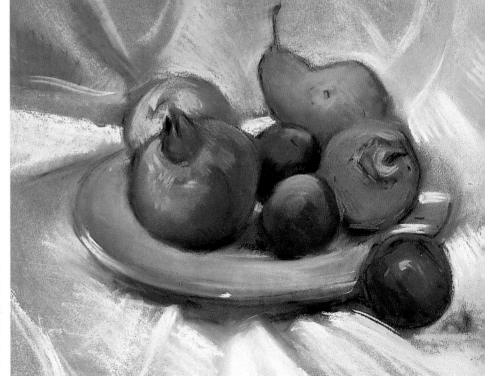

6. *Intensify the luminous effect of the pomegranate on the right with a very bright pink color. Paint some very direct white strokes on the plate. The color of the paper plays a role in this still life. Now the work is centered on resolving the tones of the tablecloth.*

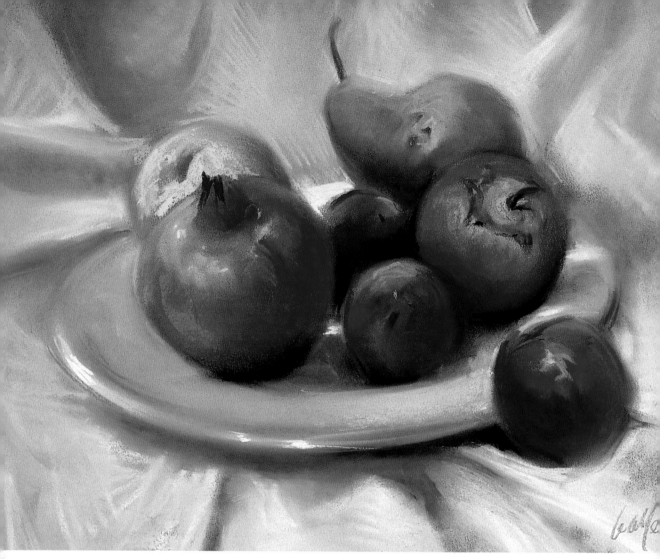

7. *Enhance the pale parts and the dark areas. Lightly blend the shadow of the plate on the tablecloth with the fingers before painting in a soft green tone. Paint a light gray on top of the plate and define the edges of the fruit by marking out the shadows. Leave some areas intact but gently blend others with the fingers to make the strokes less visible. Never go as far as to mix the colors.*

SUMMARY

Do the initial drawing by taking a lot of care and by correcting any possible errors on the plate. The precise forms are always the most awkward to achieve and are left to be done at a more advanced stage.

Sharply define the highlights on the plate. They integrate the color of the paper into the background.

Firstly, paint the dark parts on the fruit and then, immediately contrast them with luminous colors. The way you play with the simultaneous contrasts can enrich the picture.

Do the white of the tablecloth with radial strokes before blending the tone.

16

Figure studies

FIGURE SKETCHES WITH THE STICK FLAT

Very few materials are necessary to do quick sketches, and even fewer if you are working in pastel. This exercise tries to convey the essence of what a sketch is. Bear in mind that it need not be an elaborate work: just a few marks can be sufficient to capture the character of the figure. However, these marks must be placed accurately, even if this means correcting strokes already down on the paper. Pay special attention to the way the stick is used, and remember that it is the flat edge that gives the most adaptable stroke.

Sketching is one of the best ways of learning to draw a figure. Quick strokes and the spontaneous character of this way of drawing make for a very expressive motif. This is an aid when drawing highly complex figure forms. When pastel is treated as a painting medium, rather than as a drawing method, it is possible to create beautiful figure sketches without losing the properties of the stroke.

▼ 1. After having done a quick layout, develop the figure working with a flat stroke, using the whole width of the stick. Use a light color in this first addition so that on top of it you can lay on darker tones in the following steps.

▼ 2. Once the figure form has been laid out, you can superimpose new colors, which give greater clarity. In this example a slightly darker tone than the previous one has been used to trace out the shadow areas. The first tones are left in reserve. This does not mean that you cannot add luminous tones. However, if you did then you would be going beyond a mere sketch and this is not our principal concern now.

▼ 3. The final contrasts finish off the definition of the figure's volumes.

To understand and depict figures it is very useful to consult artistic anatomy books.

When doing rapid figure sketches the basic proportions of the body must be observed, although these measurements can vary according to the build of the model. However, bear them in mind in any figure exercise.

CALCULATING THE PROPORTIONS

Calculating the proportions between the different body parts of the figure will help you to do a better sketch. When you are doing rapid drawings it is very important to know the differences in the sizes of the parts of the body. Only if you get this right will the figure on the paper be more or less in proportion. A tiny or big head, or any other part of the body that is out of proportion, would turn the figure into a caricature.

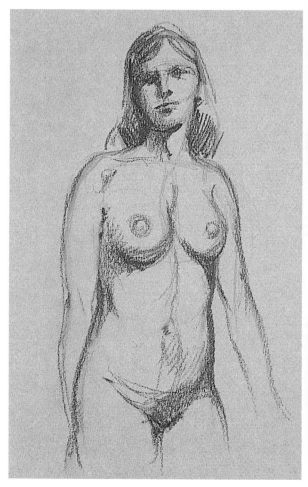

▼ 1. *Observe in this illustration the relationship between the head and the width of the shoulders. This measurement will determine the width of the whole body and is therefore highly important. On a normal body the shoulders tend to mark the maximum width of the torso, which narrows as it nears the waist.*

▼ 2. *Although the figure being drawn has a strong construction, what really counts is its internal structure. If this image is compared with the last one, the starting point for this exercise, you can see that the anatomy has changed considerably. Despite the pose being the same, it is the internal structure which determines the principal lines. The figure on the right is more corpulent but the internal structure is the same as before.*

LINES AND THE PRELIMINARY SKETCH

The best way to pick out the subtleties of the model is in the layout, which is a drawing technique all painting methods need. Up until now we have seen that a preliminary sketch helps when doing a still life and landscape elements, and this is also the case with sketches of figures in general.

1. Drawing in grid-like boxes will enable us to schematize any pose, however complicated it may be. Doing the figure in this progressive way is very useful. It makes the outcome easier to control. The few lines seen in the image on the left are easy to elaborate and understand. Working directly on the figure is a much more complicated method.

▼ *2. Once the forms of all the boxes have been set out, it is not difficult to position the different elements precisely. You must still use very simple strokes because you are not aiming at a detailed finish yet. What concerns us is giving a general understanding of the forms, which will allow us to close in on the details later.*

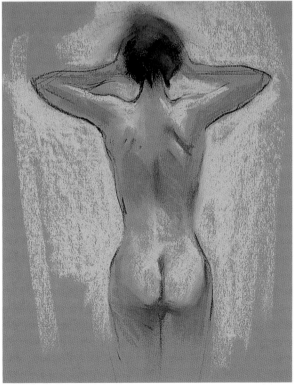

3. The lines that build the figure can be rubbed out easily or covered in new strokes. Position the light areas and the contrasts that will give definition to the figure. The color of the paper will be integrated into the overall effect.

VOLUME IN SKETCHES

J ust because we are doing a sketch does not mean that we can omit details like light and volume. Although a sketch is always done quickly and almost spontaneously, the properties of pastel make it possible to do blendings and modeling. Of course, one must not go too far otherwise the freshness and general pastel style would be lost.

▶ **4.** *At the beginning of this topic we suggested that you should start the sketch with a flat stroke to give a solid-looking drawing and to define the forms clearly. If the paper is colored, as is the case here, it can be used to your advantage to integrate the forms. Then you go on to suggest the main volumes.*

> Superimpose the main dark areas onto the sketch in such a way that the light areas are perfectly defined in the picture.

▶ **5.** *The final step is to put in the principal highlights. This process shows that when you are seeking volume in a sketch, it is not necessary to use pure white. Clear tones can take its place: indeed they play a role in the transition from medium tones to brighter areas. If pure white is used, limit it to very defined areas. As nearly all the surface has been covered, the highlights will be integrated into the volume effect of the figure.*

Step by step
A figure study

The value of the color of the objects is shown through gray strokes in the shadows and white areas in the light. To learn about white highlights we have chosen a female model. The effect produced by one unique color with touches of pastel gives a lot of volume. If this is added to the color of the paper being used, the impact is very realistic. To do the study on this page, we are going to use a restricted color range, which will enable us to observe the figure modeling without color getting in the way.

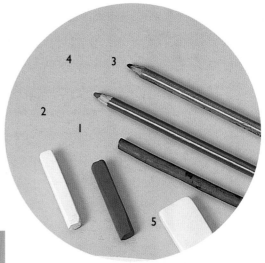

MATERIALS

Sanguine pastel (1), white pastel (2), pastel crayons (3), Havana tobacco colored paper (4), and an eraser (5).

1. To start the picture off, combine flat strokes with using the tip of the stick to outline the forms. Aim at making the drawing fine-lined, especially for the thighs and the form of the calves. You can put in the initial lines that begin to define the facial features and the hair. This will call for some precision, so use the tip of the stick, which will help you to be more accurate.

2. *Without rubbing too hard, use the fingertips to fade the most obvious strokes. Suggest the principal volumes with shading that allow the paper color to show through. You can outline the stumped areas more precisely by using the edge of the eraser. As the breasts, the back of the head and the raised arm are partly shadowed, trace gray strokes over them. The figure is then outlined by doing a general stumping over the background.*

3. *The contrast in the stumped background should be increased with soft strokes to produce a new mix which can then be blended with the fingertips. The contrasts that stand out the most are to be blended with sanguine. Model the abdomen area with a soft, dark stumping. Shade the background again and then diffuse it. Do the first highlights in white in the chest area and on the side. Increase the contrast on the abdomen and then diffuse with the fingers.*

4. *Use the black pastel stick to increase the contrast of the darkest shadow areas, thus making the high-lights seem much brighter. After doing each shadow shading, a new stumping with the fingers will blend the tone into the background and model the form of the figure. Open up new, direct highlight strokes with the eraser on the body side and the pubis. Use white to paint the principal highlights.*

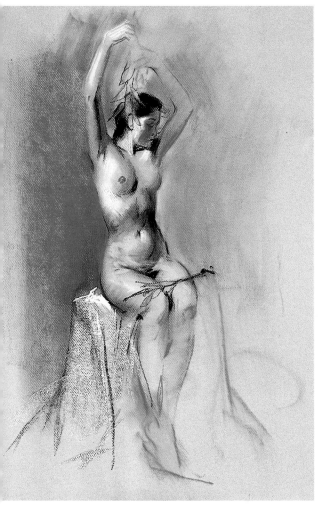

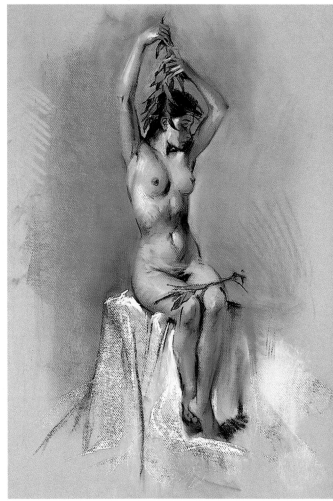

5. *Mark the boldest highlights on the face. The dark part is painted in a sanguine tone. Use a black pastel crayon to outline the forehead, the nose and the mouth. Below the head, a very luminous white, which is blended to make it more similar to the paper color, is painted. Do a new sanguine stumping in the area on the left, including the raised arm. Shade the whole seat area with the white pastel stick held flat between the fingers. Intensify the contrasts on the arms and on the navel. Model the thigh with your finger, but without totally eliminating the original drawing form. Once again use the black pastel to outline the forms of the body, the ear and some dark areas.*

6. *Finish off the face with some more highlights and by increasing the dark tone intensity. Do the shiny parts on the left hand side with direct white touches, and then define them with the fingers. The facial features are marked with the sanguine pastel pencil. If you look closely, you will notice that the legs are slightly out of proportion. This need not be a problem as pastel can be corrected at any moment.*

Colored paper is generally used in pastel pieces because the color can be integrated with the tones used during the painting process. It blends in and acts as if it were just another color.

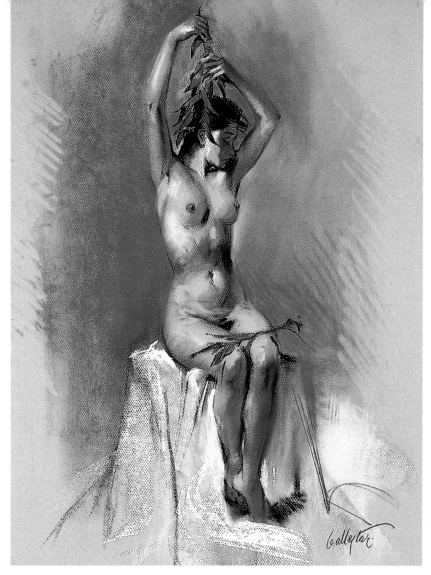

7. *The details of the figure can be done with dark and light touches softly blended into the background. Do the luminous areas of the medium tones on the legs with direct impact strokes in sanguine. Do the final contrasts in black and model the shadow areas by blending with the background. Use white pastel to do a few direct highlights on the knees and the heel. Finally, outline the hand area with the sanguine pastel stick.*

SUMMARY

This precise highlight around the navel has to be reinforced by contrasting with medium tones. The highlights not only indicate the way the light falls: they also give texture to the skin.

Use sanguine colored pastel to outline the hand area against the background.

Open up highlights with the eraser. This tool is highly useful in any pastel exercise. Besides enabling you to correct, it can also position shiny areas by taking advantage of the background paper color.

The knee highlight. This close up shows that just a simple mark is sufficient to produce a detailed effect.

17

Coloring the skin

THE PRINCIPAL LINES

When we studied sketches, we learned how to structure a figure. In this chapter we will move on to developing the form. Pay special attention to the joining of lines together, and how they are constucted from very elemental forms.

Figure is a complex theme. The basic principals related to layout and form proportion are complicated, but so too are the decisions that have to be taken when the process is more advanced, such as skin color or the need to model with light and shadows.

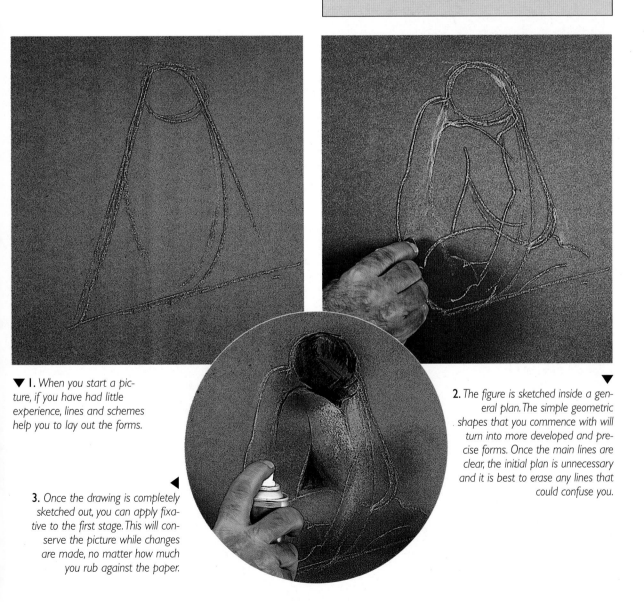

▼ 1. When you start a picture, if you have had little experience, lines and schemes help you to lay out the forms.

3. Once the drawing is completely sketched out, you can apply fixative to the first stage. This will conserve the picture while changes are made, no matter how much you rub against the paper.

2. The figure is sketched inside a general plan. The simple geometric shapes that you commence with will turn into more developed and precise forms. Once the main lines are clear, the initial plan is unnecessary and it is best to erase any lines that could confuse you. ▼

Topic 17: Coloring the skin

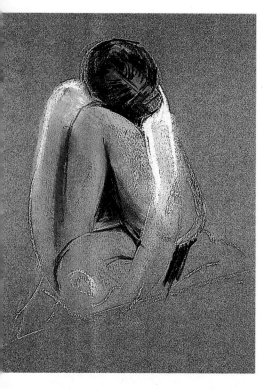

▶ **1.** The first tones to be painted distinguish between the light and shadow areas. So it is important to get the colors right from the start. Do not apply excessively contrasted colors at this stage because, although pastel is completely opaque, you could create a base too dirty to blend on top of. Moreover, the pastel color range is sufficiently wide to permit the first tone separations to be subtle.

DIFFERENT SKIN COLORS

The skin can appear to be various colors depending on the light falling on the model. We are going to color the figure we began in the last example. Observe how the lights and shadows are treated, how the highlights are intensified, and how nuances are created to tone down the directness. The color palette can be as wide as the artist wishes: it is a question of what the work requires.

3. Flesh colors, are enriched by cool and warm nuances. Blue colors bring out the feeling of a smooth and fine skin. The final detail in this study of skin colors is to paint greater impact into the highlights. equal to the dark parts. Blend some areas with the colors below but work other areas with direct color impact strokes.

▲

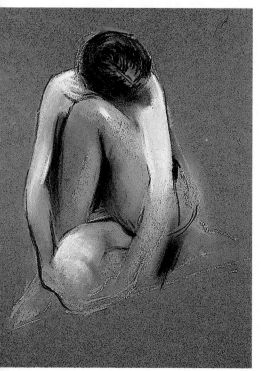

▶ **2.** Once the first skin tones of the figure are done you can paint the darker shadow colors. In some areas the aim is to form a striking and direct contrast between light and shadow, while in others you have to blend the tones.

> The skin color depends to a large extent on the ray of light that falls on the model. The highlights are produced by this lighting.

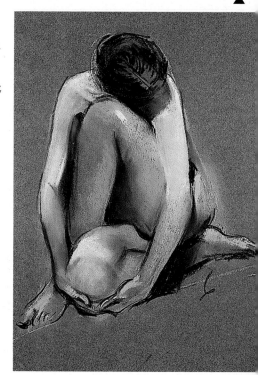

FINE DETAILS AND SOME TIPS

In this chapter we are studying how techniques related to the figure, like highlights, can give a surprisingly realistic representation of the model on the colored paper. Highlights go a long way to bestowing the desired volume effect. The following exercise practices the concepts we have studied up until now.

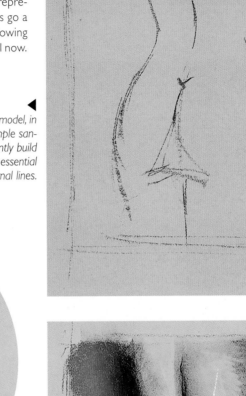

◀ **1.** To lay out the general form and the outline of the model, in this case the back of a female figure, some very simple sanguine pastel lines are traced. It is worthwhile to patiently build up any part of the body, always bearing in mind the essential form and the proportions between the internal lines.

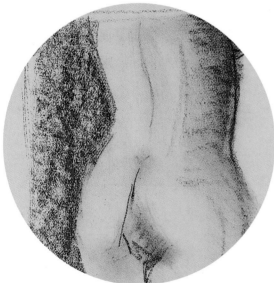

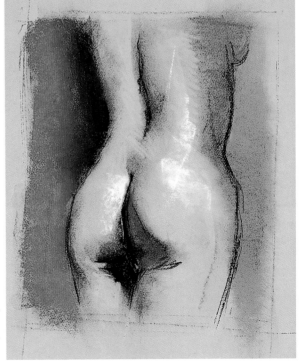

▼ **2.** Work over the dark areas with a simple and elementary stroke. This will establish the light and shadow areas. The dark background of the paper, which is finely integrated with the medium tones, outlines the body.

◀ **3.** Intensify the contrasts in black pastel. After stumping, open up highlights with the eraser and apply direct impacts of white pastel to add light. This example shows that the highlights on the figure will not cause any problems. The color of the skin has been produced by using the color of the paper.

Topic 17: Coloring the skin

When a fixative is used on pastel it is best to use a good quality brand. Quality manufacturers go to great lengths to ensure that their products do not impede the techniques being brought into play.

In this exercise we are going to draw a figure using pastel in three different ways. The beginning is very simple, and then the figure is elaborated. The first step is with just one tone: we are only trying to construct the shadows. In later stages color will be superimposed on top of other layers.

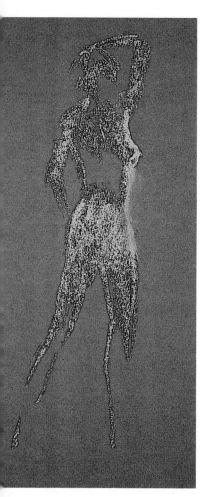

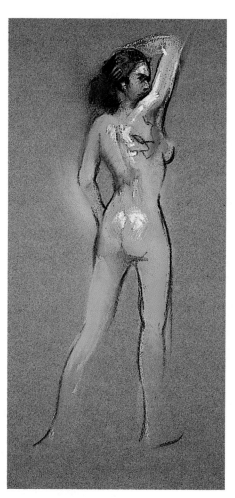

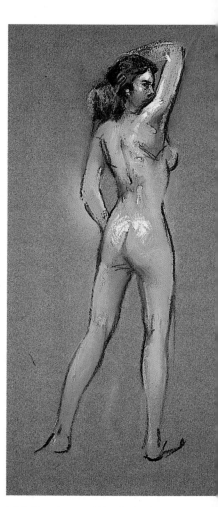

▼ 1. The figure is outlined with the pastel stick held flat. Sketching like this enables you to do a quick and well-constucted drawing. Use your fingertips to blend some areas over the paper. Where you want the highlight effect to show, use direct strokes to define the area.

▼ 2. The previous figure is going to be the base on which to practice a great variety of changes, which could almost redefine the style. Apply fixative to conserve the early work. Use luminous, brilliant colors to paint the figure with very direct strokes that do not blend anywhere. Observe how areas of color are produced that remain intact when new strokes are passed over.

▼ 3. The piece could be finished with the last step, or alternatively you could give it a different look. Some areas are blended. Others remain untouched, still displaying the energetic stroke of the original flesh color.

Step by step
Figure

Figure studies are among the most inspiring and complicated themes that you can be do in any painting media. Pastel enables you to get closer to the subject than any other method because using the pastel stick is similar to drawing. Now we are going to do a figure study with a nude model. It is fundamental that the beginner has solid references when drawing the forms. Figures can be done if you start from a good sketch.

MATERIALS
Pastels (1), clear colored tobacco paper (2), and a rag (3).

1. *In the preliminary sketch the forms are only outlined by very vague strokes. On top of this, start to use shading techniques. Of course, whenever the color of the paper is incorporated as another tone, it has an important influence on the rest of the colors. Therefore, paint around the figure in a light color to isolate it.*

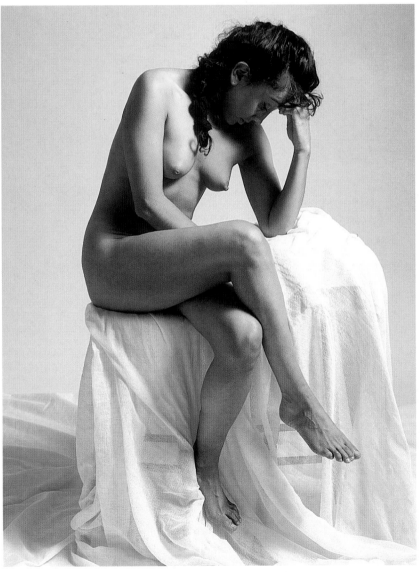

2. The luminous tone around the figure allows the color of the paper to be integrated into the overall shading effect. Observe the medium tone that runs from the thigh to the knee closely: it is the color of the paper and is going to be preserved until the end of the work. The colors applied are not random, although we are not yet trying to define the forms. Instead the aim is to distribute the principal tones, both light and dark.

3. Pay special attention to the way each color corresponds to the different light planes. Each different lighting intensity represents a different color. The maximum highlights are on the right shoulder and are painted in an orangy, very luminous pink. Temporarily paint the deepest shadows in a sanguine tone. Orange is used on perfectly defined areas of the leg, the forearm and the upper parts of the breasts. As we are not interested in defining the areas too much at the moment, the outline tones can be blended with the fingertips.

4. Once the most important tones have been shaded and their edges blended, you can go on to define the forms of the model by increasing the tone contrasts. Paint the darkest areas, like the shadow beneath the arm, directly in black but do not accentuate the tone excessively. Do the more tenuous shadows in blue, which produces a dirty gray tone. Do not forget the shadow under the leg.

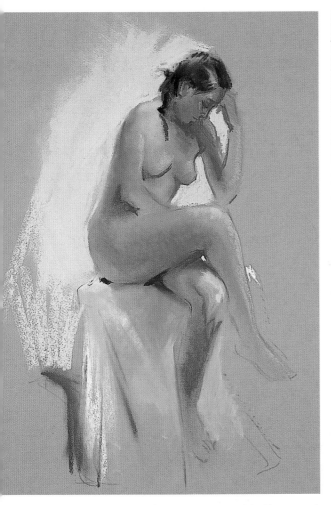

5. *The medium tone shadows on the skin of the leg are of a different type. Paint them in burnt umber. However, do not completely cover the paper color. Now it is much easier to achieve the luminous tone of the leg. Outline the bright part down to the foot. It is important to place the first highlights around the knee: they are definitive and will be the light reference for the skin highlights.*

6. *The shadow under the arm still seems too contrasted so you will have to tone it down by gently flicking the pastel with your fingertips, without dragging all the pastel. The highlights on the knee are a guide when doing new luminous spots on the right shoulder of the model.*

Depending on the brightness of the atmosphere, highlights on the skin are not worked in white because the skin filters light in its own special way.
The best approach is to use bright colors like Naples yellow.

7. Outline the leg with pure white. If you do a few luminous tone strokes and then blend with the fingers, the color of the paper will be completely merged in this area. Adding a few more highlights, like the pink tone on the abdomen and on the knee, is enough to finish off this exercise. As you can see, when you go step by step, a good skin color needs a complete range of colors, including the color of the paper. If this were not the case the lighting and atmosphere would not be realistic. The colors used, although varied, tend to belong to the same color range, taking advantage of all the contrasts. This does not mean that additions in other harmonies are rejected. That is why blue plays an important role here.

SUMMARY

The luminous tone painted around the figure allows the color of the paper to be integrated with the other tones.

The tones are established in accordance with the luminosity of each plane. For example, in the dark areas on the thigh and the arm the tone is the same.

A bright white outlines the leg and increases the contrast effect between the background and the figure.

Blend the color of the paper with the half shadows on the legs.

The way they painted

Degas
(Paris 1834-1917)

Ballerinas

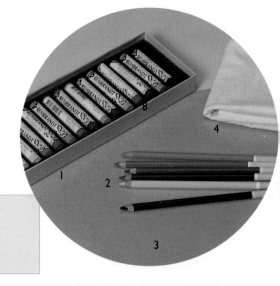

MATERIALS

Pastels (1), pastel crayon (2), clear brown colored paper (3), and a rag (4).

Degas was one of the most important impressionist artists, who is recognized for his drawings, paintings and sculptures. His first creative period was of marked historic significance and included meeting Manet, who introduced him to impressionism. The interest that he arouses in the plastic arts comes from the way he treated light and seemed able to freeze time. Highly subtle blendings are combined with expressive direct strokes. His style enabled him to work on artificial lighting and the textures that abound in the theater.

Degas was especially keen on ballet dancers and musicals for two reasons: firstly, he could study the different effects of artificial light, and secondly, he could try to make time stand still. Degas was one of the most important pastel painters. If you study his work you can see how he used color to express light and forms, working in a direct and pure style. The light creates strong contrasts, although we can not define them as chiaroscuro because there are hardly any subtle changes between the tones. This characteristic of his painting is enhanced by the fact that pastel technique allows you to work with a direct style, superimposing light tones on top of dark ones.

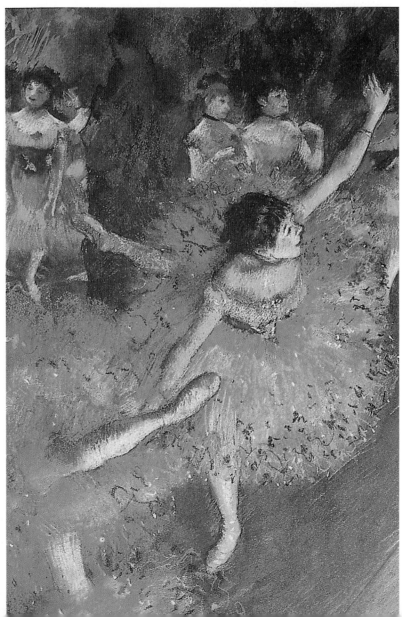

1. The preliminary sketch is very important in this exercise, otherwise it would be impossible to position the different elements in the composition. As the drawing above shows, the first step is linear. Although you could do it in pencil, try using the tip of the pastel stick. What is important is that the line is pure and simple. You can tell that Degas approached the placing and the planning of the composition at the same time. Use a brisk stroke, suitable for figures in movement, to start the painting.

2. Just as the great artist did, lay down the first color shadings as a base for later colors and to outline the color of the paper. Once both the proportions and composition of the drawing are complete -this exercise is only a fragment of Degas' work- you can start to paint in the first color strokes. Firstly, do the areas that appear to be the least complicated, such as the dark background parts. Also you can paint the dancers' tutus moving around on their legs. The effect created is interesting because it is started in blue and then green is drawn over it to produce a luminous emerald green, like the original piece.

> The colors must be blended in a very controlled way to avoid mixing them. The slightly off tones can be alternated with bright areas.

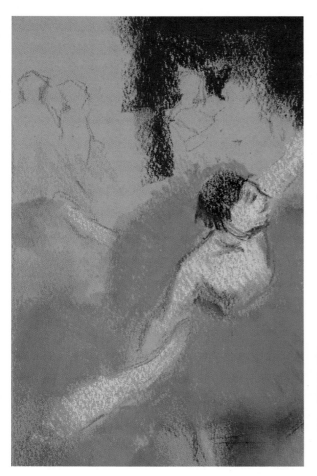

3. Degas used his vast knowledge of the technique to capture the moment. The combination of the striking color and the reserved background is effective. Where the paper grain has not been blocked out by the pressure exercised, its color optically interacts. Use this technique to paint the figures in a very luminous pink, flesh color. In the background, start work on the dresses of the ballerinas with loose orange strokes that you must blend later.

4. Paint all the lower right area in a slightly off color obtained by directly mixing blue and black on the paper with the fingers. Only stop when the pores are covered and the background color does not show through. Before doing impacting color strokes, Degas would blend some of the colors, for example on the tutus where the light is somewhat diffused. The off-gray in the foreground is allowed to penetrate into the outline of the tutu, making the form less defined.

The color of the paper must show through the densest pastel strokes so as to give the special atmosphere created by Degas in all the picture.

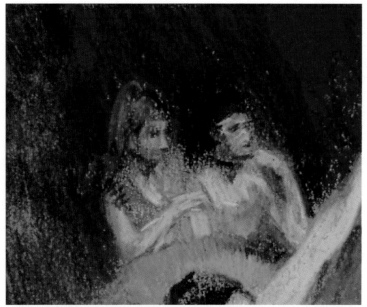

5. *One of Degas' great contributions to impressionism was the way he made light fall on the figures. Sometimes he simply depicted the distant ground with semi-blended shading. The brown color painted at the beginning outlined the two dancers hazily. Now, when the lighter flesh colors are applied, they become more defined. Due to the size of the drawing it is far simpler to do the colors with a pastel crayon. The stroke is somewhat harder and the tip will help you to do the fine, graphic details.*

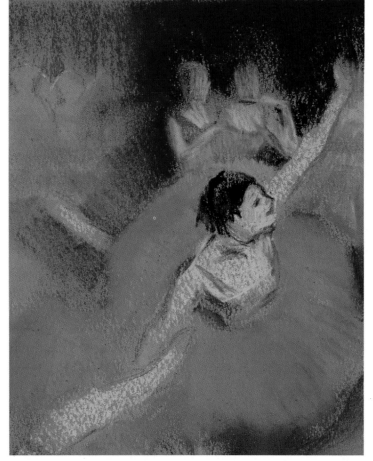

Pastel crayons are delicate tools which must be treated carefully. When the point becomes blunt, do not use a pencil sharpener: a cutter works far better.

6. *Use two shades of green to define the background on the left behind the two figures. Keep the forms that are blended over the background very simple: it is the surrounding color that must insinuate them. Do not introduce the details yet.*

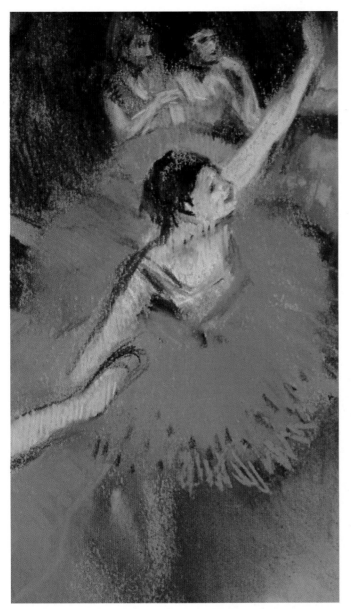

7. Use a dark pastel crayon to start outlining the figures in the background. These small contrasts, together with the short marks, outline the heads and arms; they stand out for their luminosity, and define the features. You can produce a very characteristic texture as you are combining crayon strokes with the pastel stick. Shade in different directions in each area. With loose, bright strokes start to paint the adornments of the tutu.

8. When you paint the figures, the color of the paper begins to be more prominent in their outline. Just a few touches with light colors and a few low definition blacks will give the figures the desired look. Paint the highlights almost white, without ever using pure white pastel tones.

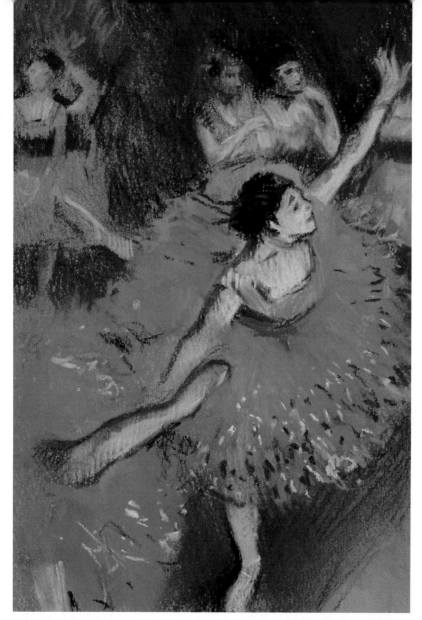

9. *It was in this final step that Degas showed his impressionist side by using pure colors that contrast with each other. Paint them with direct, superimposed strokes. The tutu is now made more luminous than before, this time using the pastel stick, which gives a much more expressive, impasted and direct stroke than the pencil. Outline the face of the lead ballerina and the body parts of the other dancers again. Use blue pastel to shade some areas on the dresses and the skin to reflect the colors of the ambience. Finally, use a bright, diagonal stroke to finish off the painting of the floor.*

SUMMARY

The flesh hue is very luminous. The color of the paper filters through.

The contrast between the figures and the background which outlines them makes the background appear brighter.

Paint the tutu in two different colors to obtain emerald green. They do not have to be mixed excessively.

The strokes of the leading ballerina's tutu are brilliant.

A diagonal stroke is used on the floor to give it texture.

The way they painted
Claude Monet
(Paris 1840-Giverny 1926)

Waterloo Bridge, London

Monet was one of the leading impressionst painters. The name of the movement comes from his painting "Impression; Dawn", 1872. He never tired of working and developing his impressionist concepts throughout his career: the way of treating light, especially moving and dancing on the surface of the water and reflecting color touches interested him. Consequently, his work has been highly influential on every generation of painters that followed.

Pastel can be applied in as many different ways as there are forms of working with fine arts. It offers as great a painting capacity as oil or any other media or technique, but, as you can see in this quick sketch, it also allows you to do direct, free and spontaneous drawings. Moreover, pastel has another advantage: it has its own unique technical effects, like the overlaying of light tones over dark ones, and the blending of colors. Monet offers a fine display of the technique of simultaneous contrasts in this spectacular but straightforward exercise in light.

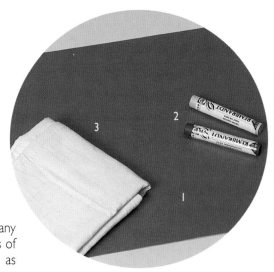

MATERIALS
Sienna-colored paper (1), pastels (2), and a rag (3).

STEP BY STEP: *Waterloo Bridge, London* by Claude Monet

1. *As pastel has a fresh stroke it can be used to draw just like other drawing media. This is a very quick preliminary sketch in which we will try to capture the essence of this famous bridge without focusing on the finer details. Although the bridge, amidst the London fog, appears simple, you must take a lot of care. Use loose strokes, superposing them but without defining the forms.*

2. *Monet worked on this painting with hardly any reference drawing, as can be seen here. The area where the Thames flows in the foreground can be shaded in white and then stumped. You must not press too hard on the stick because we do not want to cover the background color of the paper. The best approach is to use the stick flat and widthwise. Blend the tone immediately with the fingers. Paint the bridge in the same way that you have painted the water, using very luminous colors. Violet will give a clear tone under the bridge and can also be used on the right, but this time with a direct stroke.*

3. *In this painting, Monet aims to develop not so much the objects themselves but rather the luminosity. He achieved this with the contrasts produced by the light and by not excessively defining the forms. In this close up, you can observe how the reflections on the water have been done. Draw the bridge over the water with a rapid zigzag using the tip of the pastel stick. Reduce the pressure exerted as you work down. If the stroke is too obvious, gently rub it with a finger to blend it into the paper background.*

4. *Using effects on top of each other is an ever present feature in the pastel technique. This meant that it was easier for Monet to use direct strokes of light to create simultaneous contrasts. On top of a layer which is immediately diffused, put down a direct and precise layer. With the same blue that was used to sketch out the bridge, mark out the more direct areas. The strokes must now be laid over the blended tone beneath, which will become the background color.*

5. *Go over the arches of the bridge with a strong, blue contrast and increase the clarity of the light parts. As you are working on top of the color of the paper, paint until you almost block out the paper grain to ensure that the colors and tones are pure and luminous. Here the paper must not influence the shading by filtering through. Do as Monet did: leave the initial layout in place but allow the light effects to suggest the forms.*

6. *The major part of the bridge is covered with rapid, gestural strokes. The pastel colors are vibrant when they come into contact with the background color. In the upper area, paint in very luminous tones, including light violet and ivory without over using white so that strong contrasts are not produced. Use your fingertips to blend some areas of the picture. This will give the picture a foggy look.*

7. In this step, the drawing is more evident than in the previous ones. Up until now the shading and the strokes have been used as a base. Some areas are intensely blended, others less so, but what counts is that we have deliberately avoided marking the contrasts of the forms. In this painting it is the contrasts between the different light planes that play the key role, although in some areas, like on the left-hand arch, you can observe volume effects. In these areas you must work more insistently so that the shadow is more noticeable. Intensify the highlights and the contrast with the dark areas at the same time. The painting style on the water is very graphic: use the tip of the pastel stick.

8. The areas where the highlights are most luminous need not stand out yet. Although pastel can be corrected at any moment, in this piece of quick work, where the nuances are blended into the background, it is important to know how to apply the lights in the right order. Be restrained in the way you paint the direct white strokes: the contrasts with the blue, and even with the background, are sure to be noticeable. Monet's main concern was to represent the effects of the light on the objects. Observe how the direct white strokes give the necessary depth to the atmosphere.

9. *The waves on the water require more luminous colors to make the contrasts between the blues and the light areas stand out more. Moreover, by doing so, the light coming through under the bridge is more real. The* *color of the paper is left reserved for the foggiest areas. Restate the areas in blue where you want to attract the viewer's eye, while the other areas can be left clouded in fog.*

SUMMARY

The drawing is direct so that it shows the different parts of the bridge. The strokes are not concrete; instead they aim at being vibrant.

The direct strokes on the bridge enable the background to be used like the other colors.

The water reflects part of the bridge in zigzagging strokes.

The boldest contrasts are the shadows under the arches and the light that comes through

Odilon Redon

(Bordeaux 1840-Paris 1926)

The Conch

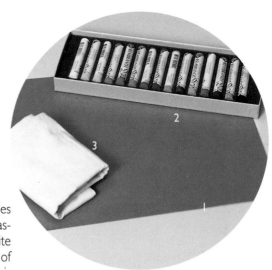

Odilon Redon played an important role in the artistic vanguard of his generation. Together with Gustave Moureau he started the symbolist movement, which later led on to surrealism as practiced by Salvador Dalí, among others.

Owing to its blending properties and impacting color contrasts, pastel was probably Redon's favourite medium. He did the greater part of his work in pastel. The realism of his paintings contrasted strongly with elements that are barely insinuated. To appreciate his work, it is also important to note the emphasis given to integrating the color of the paper into the palette.

MATERIALS

Sienna-colored paper (1), pastels (2), and a rag (3).

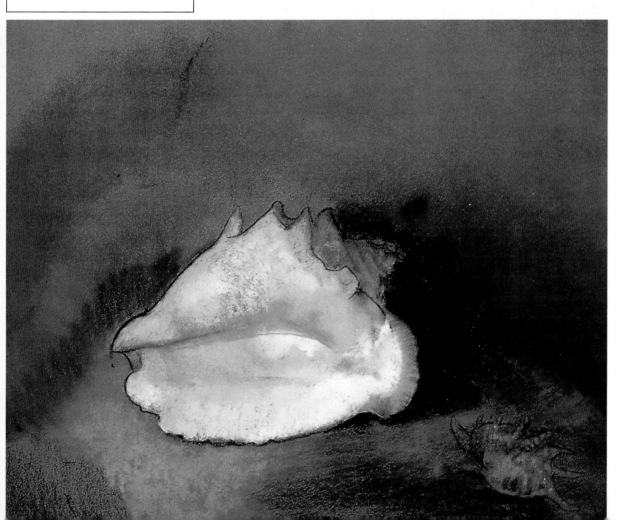

1. *One of the greatest merits of this piece is the perfect combination of shading and drawing pastel techniques. However, the drawing is not evident, nor continuous, in all areas of the picture. Instead, it appears and disappears, bestowing mystery and interest on this still life. Start the drawing with the tip of the pastel stick. Only the main lines and forms are suggested. Later on some, like the ones in the upper left corner, will be covered up by the paint.*

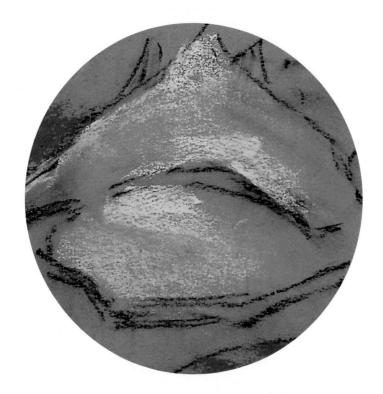

2. *How can you set about using the color? It seems that Odilon Redon preferred starting with the most evident contrasts, creating a base of both light and dark areas on which to work later. In this close up, you can see how a luminous pink color is integrated on top of the color of the paper, which will be used afterwards as the base for the pearly shell interior.*

You must be as careful when using light colors as you are with the dark ones. Working on colored paper means that both stand out strongly.

3. *Paint the background around the conch in slightly grayish green tones. When you pass your fingers over these color shadings, part of the color underneath, previously used as the initial drawing, is dragged away. The brightest areas of the conch are painted in ochre and then blended with the fingers. As can be seen, the color of the paper forms part of the picture.*

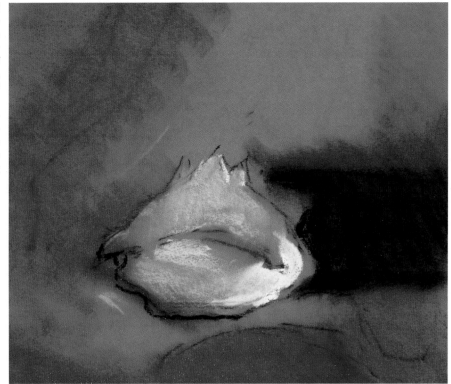

4. *It is important to carefully study the different effects of blending tones and superimposing layers. This close up is a good example of how an impasted area can just be blended at the edges with the color of the paper, leaving another area outlined against the background. Redon liked to combine blending some areas with outlining, creating an almost unreal atmosphere.*

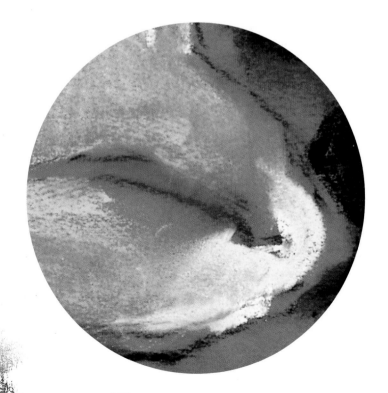

STEP BY STEP: *The Conch* by Odilon Redon

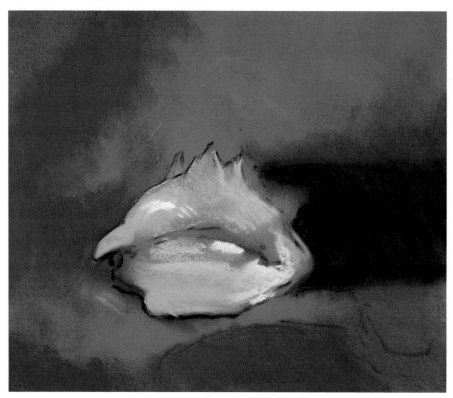

5. *Paint an intensely dark area on the right of the conch. This black tone, which is blended into the background with the fingertips, makes the conch more realistic, enhancing it with the effect of the light and dark contrast. All the background is stumped around the shading so the attention is focused on the main object, which will be painted with visible strokes throughout the exercise.*

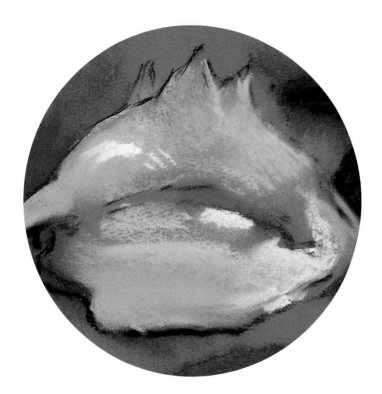

6. *Instead of allowing the stroke to disappear, make the edges more marked, increasing the impact of the contrast between the two styles. After diffusing the whitish tones, including pink and a bone-like color inside the conch, paint the left of the conch ochre. This addition is blended over the background before putting in a few new bone-colored touches. The edges of the inside of the conch are restated and then the lighter tones are diffused.*

7. *Pastel is easy to handle since it never has to dry on the paper. This permits you to merely wipe it quickly with a cloth to open up a clear space in which to redraw the small conch on the right. It is not a strong focal point, but it adds balance to the picture. If the black becomes too clogged when you wipe it, use the eraser. However, do not make the light space too bold.*

8. *Now the work is focused on the background around the conch. Paint it in blue tones, adding a little black and a color similar to the color of the paper. In this step you can appreciate how Redon approached the subtle blending of a great variety of pastel tints. Playing with the colors in this way creates a fascinating visual rhythm all over the picture. Inside the conch, diffuse any edges which are too hard with your fingertips.*

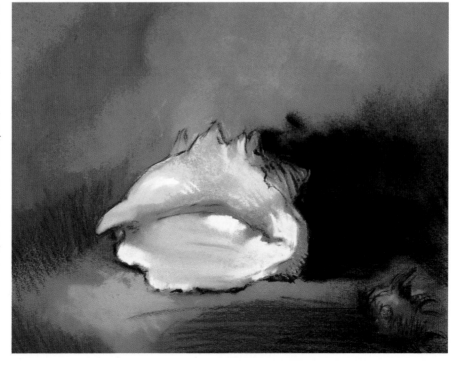

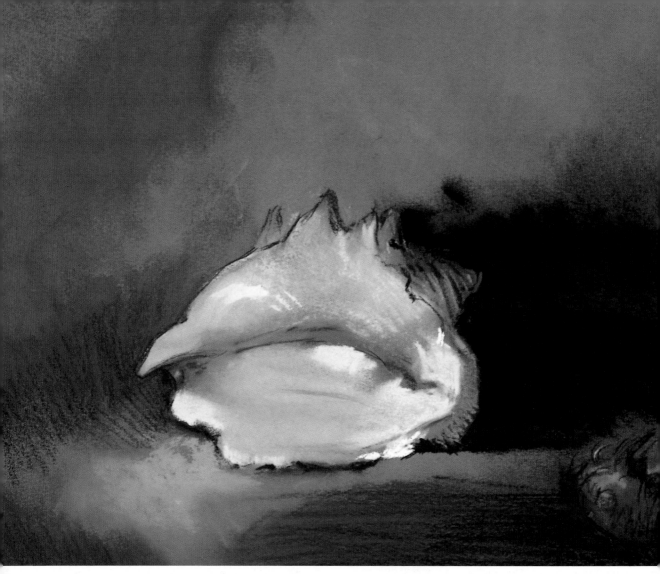

9. *Do the definitive contrasts for the whole picture. The background is painted again to avoid unnecessary mixes. Use black to darken the deepest shadows and sanguine colored pastel to paint the brightest parts,* *allowing the color of the paper to filter through. To increase the contrast of the conch in the lower part of the background, use a more orangy tone.*

SUMMARY

Do the drawing in black pastel. Some of the areas will later be covered by the background.

In the background there are colors that strongly contrast with the highlights on the conch.

The edges of the conch are constantly restated, but let the stroke remain visible.

Inside the conch the very luminous, diffused color is a base for other more varied and precise tones.

The way they painted

Joaquim Mir
(Barcelona 1873-1940)

Landscape

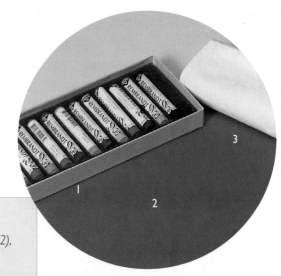

The origin of Mir's paintings lies in the natural brightness of the light in the Mediterranean countries. His original subjects are pictorial testimonies based on life in the neglected areas of towns and suburbs. The special color contrasts were in themselves worthy of interest. Symbolism and modernism heavily influenced his work making it more energetic and fantastic.

MATERIALS

Pastels (1), blue-colored paper (2), and a rag (3).

In this work Mir reveals his interest for the way light filters through the trees. Pastel enables him to apply light areas superimposed on top of dark areas, sometimes painting them and sometimes taking advantage of the color of the paper. This pastel landscape is a clear example of why it is regarded as a fresh and spontaneous way of painting, full of little dashes of color and impacts of light. You will be able to distinguish the different ways the paint has been treated. Some areas are clearly drawn and the line is visible. Other areas are informal shadings. What makes this piece difficult to do is that the composition of the picture is not based on planes, but rather on shadings which are not related to each other in an obvious way as in other more realist or figurative pieces. It is important to study the tones of the light and how the color of the paper shows through.

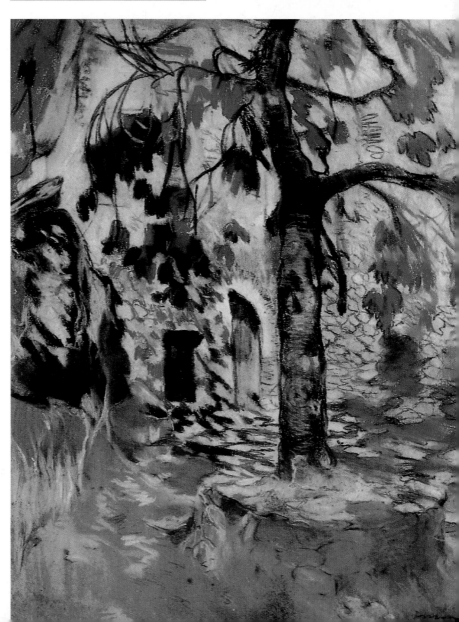

1. *You must always try to find the internal composition of the objects you are going to interpret. If you look for the principal lines you will be able to depict them much better. The first stage of the drawing will be done in a luminous blue color which gives a bold contrast and can later be easily integrated into the picture. It is probable that Mir did a preliminary sketch similar to this one since the final result is abstract and requires precise preliminary work.*

> The composition layout should
> be done in tones similar to
> that of the paper, or in colors that
> can later be integrated.

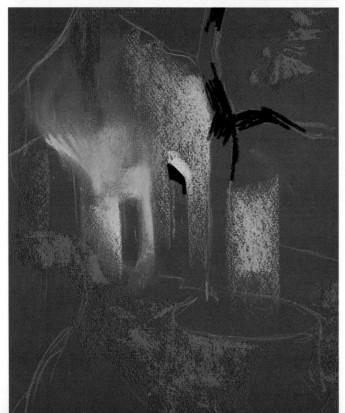

2. *It is necessary to finish the previous plan before going on to approach the first tones of the picture. Mir shaded the first light areas to isolate the forms on the paper, and to provoke an interaction between the background color and the rest of the colors in the picture. Later, you will be able to observe the progressive increase in the harmony of the paper color with the color and tonal theme. The first shading is done with the stick flat between the fingers. Rub the dirty white of the house with your fingertips so that the stroke mark is not noticeable.*

3. *When Mir blended colors into the background, all of which belong to the cool color harmony, he excelled in their integration. The large shading in the lower part is painted in one color that hardly contrasts with the blue of the paper. However, the upper part is more diffused and here the green tone used below is deliberately mixed with Naples yellow.*

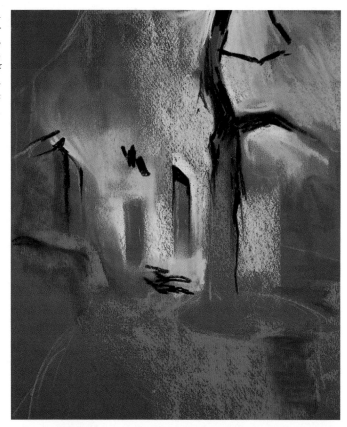

Blending the colors together must be combined with direct shading to enable you to outline the shapes against the background as if they had been painted.

4. *In this close up you can observe how the principal tree in the landscape is painted. Once the trunk has been painted green, (the color that will later be the base for the texture treatment), use your fingers to drag some of the black out of the branches. The two tones blend in such a way that the black from the upper part of the tree gently gradates over the green.*

STEP BY STEP: *Landscape* by Joaquim Mir

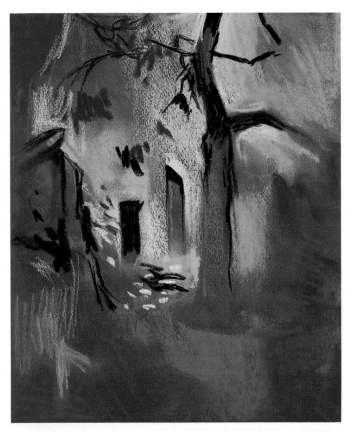

5. *The forms of the picture start to become clearer when you paint the first black contrasts in the doorway and in the shadow around the entrance on the right. Black integrates the color of the paper even more. At the same time, use white pastel to do luminous dashes on the ground. Use your fingertips to blend the colors where the flat strokes were visible before. Mir created the atmoshere of the light by using luminous colors combined with dark strokes and the color of the paper. The bright shading of the ground reveals the way the Spanish painter worked.*

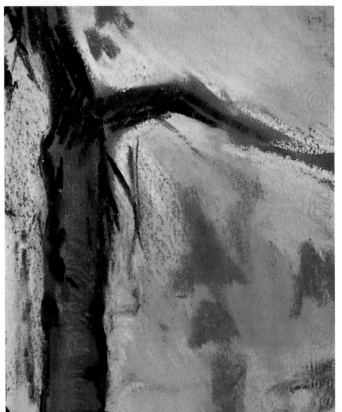

6. *The strokes on the main tree are made once the contrast against the background has been strengthened. The outline of the tree trunk must be blended by rubbing the finger inwards, towards the center. Paint on top of the bark in a blue which is very similar to the color of the paper. On top of this paint in green.*

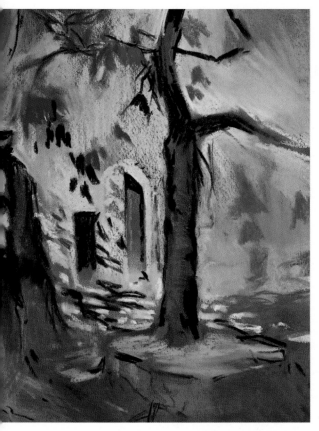
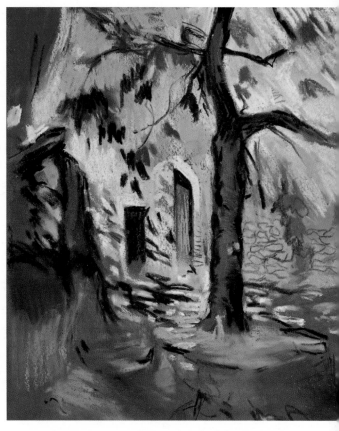

7. *Paint the white parts of the wall in an ivory white which allows the background to filter through in several places. These whitish tones are blended with the background so that the edges are not noticeable. Blue pastel is used to blend some of the shadow areas with the color of the paper. As well as these additions of blue, very direct strong contrasts are created by using pure white strokes, which are left unblended, and black dashes.*

8. *In the previous step you started to paint the walls white. Now, on top of these greenish white blendings do more shading, but this time with more direct strokes. The white strokes must be long and sloping, while the green is applied very directly with the tip of the stick. Mir blurred away the edges of the fallen leaves to attain the effect he desired. Use the tip of the stick to begin to outline some areas on the right, like the branches or the stone wall.*

The contrasts and the most detailed
areas must be left until the end
as they give the final shape to
the objects painted over the shaded
areas in the picture.

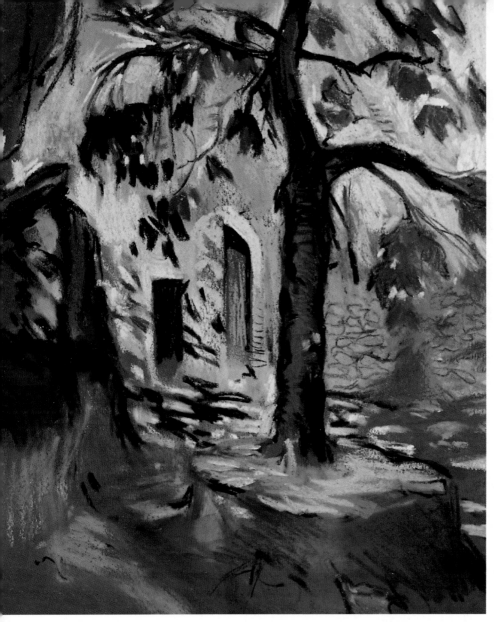

9. *To finish off this laborious pastel piece, paint some loose green strokes in the area of the branches. Blue is used to restate some shadows and to further integrate the color of the paper. In the lower left corner, work on the grass and the textures which are partly blended in with the first layers. Apply some direct lines over this base. Just doing a few more contrasts and direct color dashes is enough to round off this interpretation of Mir's work.*

SUMMARY

The drawing is made in a bright color from the same chromatic range as the color of the paper. This means that when the other colors are painted they will cover up the lines.

The blue of the paper is always left filtering through and is integrated into the chromatic spectrum.

The first color marks are luminous. Blend them over the background to prepare a base for more direct colors.

Adding blue to the shadow areas helps the paper to work in harmony with the color and tonal theme.